MW00807962

ISLAND ZOMBIE

ISLAND ZOMBIE

ICELAND WRITINGS

RONI HORN

PRINCETON UNIVERSITY PRESS
PRINCETON AND OXFORD

Copyright © 2020 by Roni Horn

Weather Reports You originally published by Artangel/Steidl,
London and Göttingen, Germany © 2007 Artangel/Steidl,
and Roni Horn

Requests for permission to reproduce material from this
work should be sent to permissions@press.princeton.edu

Published by Princeton University Press, 41 William Street,
Princeton, New Jersey 08540

In the United Kingdom: Princeton University Press,
6 Oxford Street, Woodstock, Oxfordshire OX20 1TR
press.princeton.edu

Jacket illustration: No. 14, *Iceland's Difference*,
August 31, 2002, in *Morgunblaðið*.

Jacket design by Takaaki Matsumoto, Matsumoto
Incorporated, NY

All Rights Reserved

Library of Congress Cataloging-in-Publication Data
Names: Horn, Roni, 1955- author.
Title: Island zombie : Iceland writings / Roni Horn.
Other titles: Morgunbladid.
Description: Princeton : Princeton University Press, [2020]
| Includes bibliographical references and index.
Identifiers: LCCN 2020002286 (print) | LCCN
2020002287 (ebook) | ISBN 9780691208145 (hardback) |
ISBN 9780691208978 (ebook)
Subjects: LCSH: Horn, Roni, 1955- | Iceland.
Classification: LCC N6537.H644 A35 2020 (print) | LCC
N6537.H644 (ebook) | DDC 709.2—dc23
LC record available at https://lccn.loc.gov/2020002286
LC ebook record available at https://lccn.loc.
gov/2020002287
British Library Cataloging-in-Publication Data is available

Designed by Takaaki Matsumoto, Matsumoto
Incorporated, NY

This book has been composed in Adobe Garamond Pro
Printed on acid-free paper. ∞
Printed in the Czech Republic
10 9 8 7 6 5 4 3 2 1

CONTENTS

Introduction
 Island Zombie 1

Pooling Waters
 Making Being Here Enough 11
 Sometimes Dead 13
 The Cold Blood of Iceland 15
 Bluff and Psycho 17
 How—Is Visible Here 19
 Floating in the Desert 23
 Accidents Are Mundane 25
 Roads Lack Dedication 27
 Little Showers 29
 Falling Trees Make Sound 31
 Verne's Journey 33
 The Probability of Round Rocks 35
 Special Effects 37
 Lóa and Lóa 39
 Weather Is National Sport 41
 Anatomy and Geography 43
 Indoor Water 45
 Pronouns Detain Me 47
 Bluff Life 49
 A Newark Here 53
 Island and Labyrinth 55
 Where the Earth Is Hot 57
 Youth and Geometry 59
 Sleep: Rotation Method 63
 When Dickinson Shut Her Eyes 65
 Pastoral and Cave 67
 The Flats (After William Morris) 69
 Crossing a Field I Remember 71
 I Can't See the Arctic Circle from Here 73
 A Franchise of Rainbows 75
 Wallace Stevens's Ice 77

Collected

Hot Water Sampler 85

An Adhesive Feeling 89

A Mink Look 91

Mirror, Desert and Mirror 93

Monroe, Iceland 97

Throwing Itself Together 99

Something Shimmering 101

An Evening with Gelatinous and Glutinous 103

Cloth-Home Culture 105

The Other Here 107

Water and Clearing (Excerpt) 109

Conjecture a Cause: Seljavegur 2,
 Reykjavík 101, August 22, 2003 111

Notes on the Obsolescence of Islands 115

Eruption, Assassination (November 1963) 119

A White Stone 121

My Oz 125

Weather Reports You (Excerpt)

Introduction 135

Selection: 21 Reports 137

Morgunblaðið **Newspaper**

Note on Texts 180

The Nothing That Is 181

Notes on Icelandic Architecture (Excerpt) 187

One Hundred Waterfalls, Five Hundred Jobs 189

Iceland's Difference 195

Colophon 246

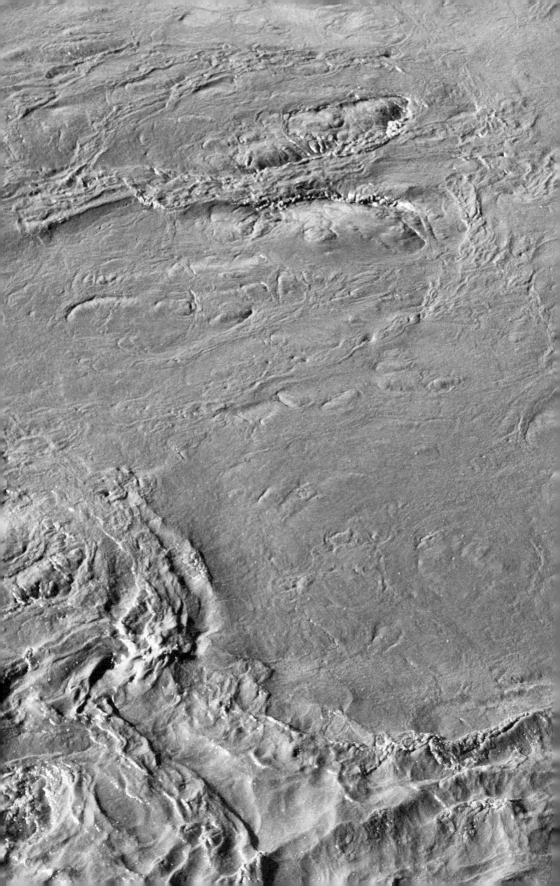

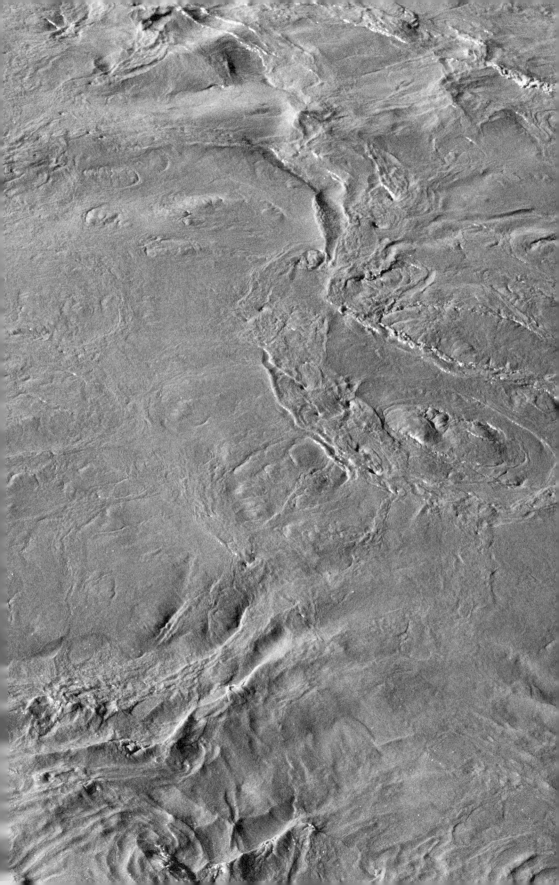

ISLAND ZOMBIE

1

My first venture abroad was Iceland. It was 1975 and I was nineteen. My memory of the trip is dominated by weather. The sky, the wind, and the light all made a strong impression. Weather simply hadn't occurred to me before then.

In 1978 I received a grant from graduate school. I used it to return to Iceland the following year. For six months I roamed the island. With a dirt bike modified for long distance travel, I was portable; I lived in a tent furnished with candles, sleeping bag, and cook stove, pitching camp wherever I tired.

It was a solitary journey. The roads were unpaved. The bike was well suited; with no limits on access, I went everywhere. The distinction between public and private hardly existed then, and never restricted direction. Anywhere was possible.

Except for short interludes, I was outside 24/7, exposed to the inclement weather, the riotous force of the wind, and the loud whining of the two-stroke engine. The roads, not fit for distance, made travel demanding and slow. That spring and summer, the seasons of my journey, were claimed as the coldest and wettest in the island's recorded meteorological history. With no grading the dirt roads hugged the natural contour of the landscape. The local ups and downs greatly slowed horizontal progress. With distance attenuated in this manner, arrival lingered endlessly off in the distance.

I returned to Iceland with migratory insistence and regularity. The necessity of it was part of me. Iceland was the only place I went without cause, just to be there.

Early on I imagined compiling an inventory of rocks and geologic debris. Each rock was that compelling. Travel was crowded with attention-grabbing views

and weird organic formations. To date there is no inventory, only the dream, though I remember them. I remember the rocks.

In 1982 the national chief of lighthouse keepers gave me permission to stay in a lighthouse off the southern coast. For six weeks I lived up on the bluff at Dyrhólaey. The building, from the early part of the twentieth century, included living quarters. But when the light was automated the lighthouse went uninhabited for decades.

I arrived in early May. And since I wasn't going anywhere, it soon began to feel like an act of submergence—going deep but not going far. Staying put among local change was travel. The bluff was action packed. It was a matter of attention. Between the water and the light, the birdsong and the wind, the rocks and the weather. Between the sand and the seals and the eider and the puffin, I was busy.

In the mid-1980s I began work on *To Place*: a series of books—an encyclopedia of sorts, based in what would become a lifelong relationship to the island. The first volume, *Bluff Life*, was published in 1990. Currently it is ten volumes deep.* I'm not anticipating an end to it since I've discovered, paradoxically, that *To Place* becomes less complete with each new volume.

By the early 1990s Iceland had become quarry and source. At times travel seemed closer to hunting or mining. Extraction, I thought, was the basic act. The drawings, sculpture, and photographic work I was producing at the time† integrated the presence of the island and the experience it offered. But as I view the dynamic now, the reality was quite different: Iceland was a force, a force that had taken possession of me.

2

I recall the first image I associated with Iceland from childhood. It was that of a horizonless ocean at the center of the earth. I knew it was Iceland because Jules Verne had decided, discovered, or determined that the *entrance to the center of the earth* was located there. With all the years and all my travels, the truth of this insight has only deepened.

I'm often asked but have no idea why I chose Iceland, why I first started going, why I still go. In truth I believe Iceland chose me:

> The island.
> The ocean surround.
> The going north.
> The light.

The emptiness.
The full-up vacancy.

The wholeness.
The absence of parts.

The wholeness of something entire.
The completeness of something whole.

The frequency of white.
The whiteness of white.

The open space.
The nothing of open space.
The accumulation of nothing.

The nothing plus nothing that is still nothing.
The nothing plus nothing that is still transparent.

The horizon.
The horizon that always exaggerates the proximity of the horizon.[‡]

The possibility of infinity.
The visibility of infinity.

The visibility of the weather.
The visibility of other worlds.
The sense of seeing beyond sight.

The plain circumstance.

The now.
The perpetual now.
The unsuspendable now.
The no-other-than-now.

The treelessness.
The treelessness that provokes no desire for trees.

The views.
The views in the scale of the planet.

The openness.
The continuity.
The fool-me-endlessness.

The being faraway.
The feeling of being surrounded by faraway.

The sense of place.
The palpable sense of place.
The with-my-eyes-closed-sense of place.

The possibility of being present.
The sense of being present.
The being present.

The unsolicited awareness.
The ineluctable awareness.
The sheer awareness.

The solitude.
The solitude of distance.
The solitude of only.
The solitude of no way back.

The cool air.
The cold air.
The nothing but air air.
The air that is spirit not thing.

The wild, wild air.

The largeness of the moon.
The closeness of celestial bodies.
The light from non-terrestrial sources.

The shadows.
The darkness of shade.
The darkness of light withdrawn.

The black earth.
The black sand and the black ash and the black rocks.

The pink pumice.

The unnatural looking natural red earth.

The rocks.
The rocks shaped to platonic stardom.
The rocks in their organic ambiguity.

The basalt everywhere.
The basalt with its liquid past.
The basalt: cool and cracked, and whole even when in pieces.

The erratics.
The always solitary erratics.

The desert.
The unbroken emptiness of the desert.
The not nothing of the desert.

The absence of threat.

The absence of threat.

The mystery.
The mystery that is chaperone.
The mystery that accompanies the light: dark and bright.

The wind.
The delicacy and violence of the wind.
The indifference of the wind.

The stillness when it is still.
The silence when it is still.

The weather that is wildlife.

The weather.
The weather—sublime and dangerous, wild and unknowable.

The simplicity.
The clarity.
The youth.

The chance.
The opportunity.
The desire.

The absence of the hidden.

The absence of secrets?
The feeling of the absence of secrets.

The unused.
The unoccupied.
The uninhabited.

The absence of hierarchy.

The transparence of time and space.
The transparence of place.

The crazy infant geology.
The unworn and the broken and the always complete geology.
The self-evident geology.

The water.
The water.

The water.

•

Q.—*What is a soul possessed by isolated insentient forces?*
A.—*An island zombie?*

<div align="right">(2020)</div>

* Vol. 2: *Folds* (1991); Vol. 3: *Lava* (1992); Vol. 4: *Pooling Waters* (1994); Vol. 5: *Verne's Journey* (1995); Vol. 6: *Haraldsdóttir* (1996); Vol. 7: *Arctic Circles* (1998); Vol. 8: *Becoming a Landscape* (2001); Vol. 9: *Doubt Box* (2006); Vol. 10: *Haraldsdóttir, Part Two* (2011).

† The photographic installations: *You Are the Weather* (1994); *Dead Owl* (1997); *bird* (1998–2008); *Pi* (1998); *Becoming a Landscape* (1999–2001); *Her, Her, Her, and Her* (2002); *Doubt by Water* (2003); *Herdubreid at Home* (2007); *You Are the Weather, Part 2* (2010); *Mother, Wonder* (2012/19).

‡ Paraphrase of Edmond Jabès.

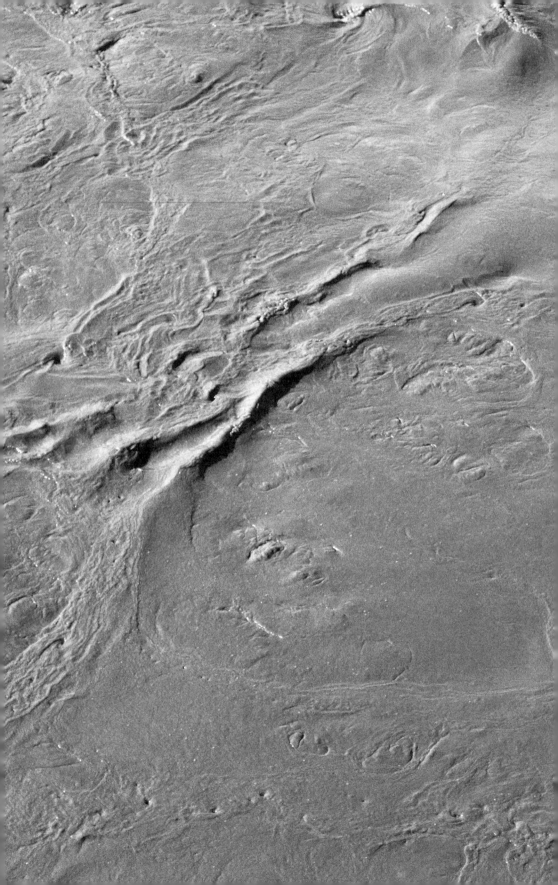

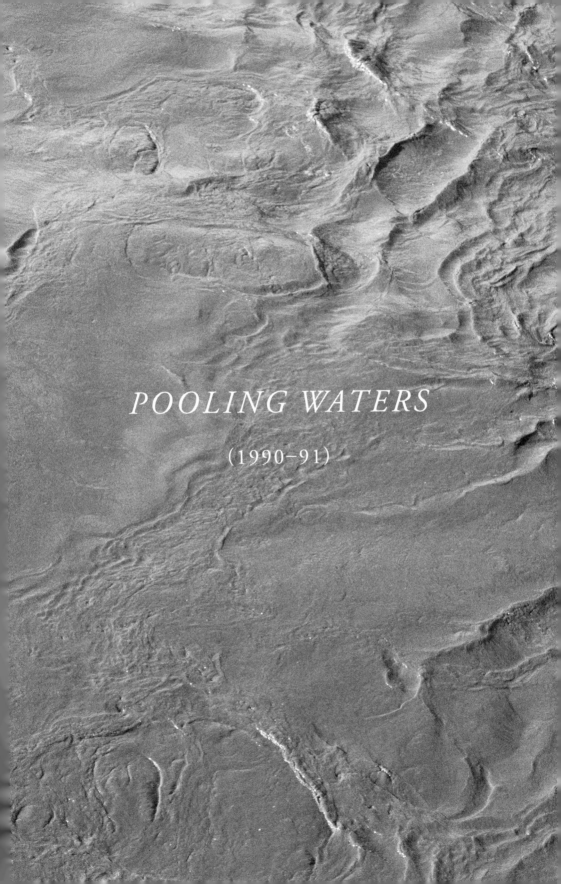

POOLING WATERS

(1990–91)

MAKING BEING HERE ENOUGH

I don't want to read. I don't want to write. I don't want to do anything but be here. Doing something will take me away from being here. I want to make being here enough. Maybe it's already enough. I won't have to invent enough. I'll be here and I won't do anything and this place will be here, and I won't do anything to it. And maybe because I'm here and because the me in what's here makes what's here different, maybe that will be enough, maybe that will be what I'm after.

But I'm not sure. I'm not sure I'll be able to perceive the difference. How will I perceive it? I need to find a way to make myself absolutely not here but still be able to be here to know the difference. I need to experience the difference between being here and not changing here, and being here and changing here.

I set up camp early for the night. It's a beautiful, unlikely evening after a long rainy day. I put my tent down in an El Greco landscape: the velvet greens, the mottled purples, the rocky stubble.

But El Greco changes here, he makes being here not enough. I am here and I can't be here without El Greco. I just can't leave here alone.

SOMETIMES DEAD

A sunny blue morning and I'm looking for a place to rest. On the map there's a beach not far ahead. I leave the road and drive across a grassy field and soon I'm on a red-sand beach. The tide is out, the ocean far away. I get off the bike and wander down the shore. It's windy and cold, but the sun is warm in a cloudless sky. The arctic terns are about, they screech and hover and swoop down at my head.

I lie down on the sand; near the earth the wind is still. I fall into a deep, brief sleep. Through my eyelids the bright light of the sun saturates my body. As though from outside, I see myself translucent and feathered red to orange at the edges of my silhouette, a science fiction. I dream of my body inanimate, prone, giving up its opacity.

As I wake I feel a weight on my chest. And there, as my eyes slowly open, is a large brown bird perched on my stomach. It casts a shadow over my face. I lift my head as the bird takes a peck at my chest and wonder is this in life or in death? I panic and the bird spreads its wings, digging its perch in a little deeper as it takes off.

THE COLD BLOOD OF ICELAND

There are no reptiles here. No snakes, no crocodiles or alligators. No lizards, turtles, or frogs. No mammals that could hurt you, either. The people are rarely criminal and only occasionally violent, and almost never toward a stranger. There are no serial murderers here, maybe a few crimes of passion here and there, but no decapitated women or otherwise mutilated bodies. Essentially there is no violence. No irrational threats. No intimidating predators. No cold-blooded animals. All the things that aren't here resolve what is. Relief from fear is freedom.

But there's something else here: the weather. The weather is here instead—a Freudian slip of ecology. As though weather was wittily and mercilessly substituted for reptiles. Weather, a natural force magnified by island circumstance, is the cold blood of Iceland. Weather with its amoral, wanton violence is lethal here.

Weather moves rivers and makes them, too. Weather blows roads away or turns them into mud. It washes the rocks out of the mountains and dams the roads. The weather is one thing here and fifty feet away something else. Cars are blown off roads, frequently in some places, and people are picked up or knocked down by sudden gusts. In the interior, near the glacier for example, the winds can get so bad you must crawl on the ground to get through. Sandstorms stop visibility a foot in front of your face; this is a way of being lost without having gone anywhere. When the glaciers begin to melt the earth trembles at the gushing vehemence of engorged rivers. Water is thrashed out of the ocean and thrown in the air, whole fields of water are blown out of lakes. Waterfalls are smashed into fine spray and blown back up into the clouds.

Changing weather can strand you quickly. Just around the bend a whiteout might erase the world entirely. Sometimes briefly, sometimes not. Rivers can turn into lakes, and so can fields. When a field becomes a lake it's intimidating just

standing near. These instant lakes have properties unpredictable and unmapped. Encountering these new bodies of water presents a unique form of being lost. You are lost not because you don't know where you are but because where you are is not what it is.

BLUFF AND PSYCHO

I'd been living on the bluff only three weeks when I ran out of reading material. I searched the lighthouse for possibilities. Up in the tower I found the repair manual for the electric generator (good over breakfast, but not more) and *True Life, Unsolved English Murder Mysteries*. It would be hard not to read the mysteries, I thought. I spent the better part of the evening resisting. But then . . . I succumbed—hideous, detailed descriptions of wives cut into pieces and sent around town or stashed under bridges by their husbands, often doctors.

In the room overlooking the bluff, I sat and read. The mood was intensified by the thick fog that was presently enveloping the bluff and obscuring the view. I was dreading the moment I would finish. My only option, I knew, was to keep reading and rereading, and just not stop.

Though I lingered purposefully over each criminal act, savoring the occasional and extraordinary detail, I finished quickly. These terrible images—headless women, body parts washed up on the Thames, disemboweled torsos—populated the bluff. The lighthouse diminished in size, a claustrophobic energy entered the building.

I sat still, very still, listening to the late-night silence of the room. It was loud and tiring. I waited for a break, a way out, a pause in the feeling of terror that filled me. It came quickly when the electricity shut down and the building went dark. Seconds later the electric generator exploded into action, a twisted parody of my fear and helplessness. It was unbearably loud and intense. I laughed and laughed and then I froze. My muscles strained with immobility.

I sat in the dismal bare-bulb light staring into the darkness, into my reflection in the glass. Intermittent bursts of white swept past the window and over the bluff, racing around the room and washing over my face.

HOW—IS VISIBLE HERE

I'm standing on the mountain Kerlingarfjöll, high up in the interior of Iceland. A warm, sunbaked evening fills the air. The atmosphere is a lens, focusing the view into vivid and stunning clarity. The air is thin and transparent, so much so, it feels new. Things far away are as visible as those that are near. There's little distinction between the two.

Looking around I can see the ocean way out there, in all directions. With a sense of omnipotence, I can also see everything in between. No haze, no dirt, no trees, nothing obscures the view. I am seeing all that is visible in each direction, as far as that direction goes. Only the curvature of the earth diminishes and eventually removes the most distant part of each view.

To the east the view is briefly interrupted by the mountain I'm standing on. But every little thing on the mountain stands out in magnified clarity too. The blades of grass, the grains of sand, the perfect pebbles, each rock, and every flower, and every part of every flower are brilliantly visible. I can see the smooth, rough, and granulated textures of all things: the earth, vegetation, and rocks. I see this simultaneously and without hierarchy. Every road, lava field, lake, and river, every glacier, mountain, boulder, and bridge, each holds its place in the view.

Provided it's the right arctic atmosphere, you can stand almost anywhere on this island, not necessarily high up, and experience these deep views. The terrain is an ocean of expanse; an expanse interrupted only occasionally by a mountain or a glacier. And only rarely do buildings or vegetation interfere, and trees never do.

There are no trees in Iceland. Their absence brings out the remarkable nature of this landscape. *The views here are the trees of Iceland.* In other places no trees creates a vacuum, obscuring the view with longing and desire.

Iceland is young; some of the island is less than thirty years old. Surtsey was cooling its molten mass into the Atlantic Ocean within months of John F. Kennedy's assassination in 1963. Iceland's so young erosion hasn't yet obscured the origin of things.

Youth and no trees reveal things rarely seen anywhere. Like how a place comes to be, continuously.

How the landscape takes shape.

How the lava flows and where it stops. And how many times it flows here or there, because each flow is a layer, looking like a single step in a staircase.

How these layers and steps now laminated into a solid mass tilt this way or that.

How the water emerges from underneath a lava field and forms a wall of waterfalls.

How the earth splits open in a miles-long, straight, v-shaped canyon.

How molten lava rides the rivers out to sea.

How boiling water spontaneously jumps out of the earth.

How basalt cools into accordion walls of architectural clarity and scale.

How lava flows over wet earth and becomes a field of breasts and cones that together create an undulating and sexy horizon.

How fjord mountains stop happening way up in the air like the blades of upturned knives and how these sharp mountains form a row of pinnacles like the teeth of a comb.

How a lava flow becomes a maze.

How a mountain breaks down into particles that settle into vast slopes in dazzling angles of repose.

How, precisely, tectonic plates—enormous pieces of global crust, come together exactly as one might expect the edges of some enormous crack to do.

The *hows* build up everywhere, forming a landscape of infinite depth and transparence. Each how takes you one step deeper, beyond appearance, beyond the simple visibility of things.

No trees. No trees introduces something as complex and necessary as trees themselves. But when this absence combines with the right atmospheric conditions, Iceland grants omniscience to the visitor free of superior forms.

FLOATING IN THE DESERT

It was late in the night when I saw the moonlit steam wafting in the distance. The road of black ash switched back and forth as I drove the soft slow miles of the desert. Descending into the valley the dark mounds gradually parted and an oasis appeared: a painted concrete pool centered itself in the landscape. Set in a very green grass windbreak it was surrounded by a picket fence. Steam billowed turbulently from an unseen source tucked behind the changing rooms, offering the oddly serene feeling of perpetual cloudiness. I climbed over the picket and undressed in the darkness. The frost-covered grass burned my feet. I dove into the hot water and sulfur smell. Underwater, warm and weightless, I come up floating, my breath precipitating water from the night. My eyes open to the luminous night sky. All the stars are in their place up there. A faint drizzle is falling.

ACCIDENTS ARE MUNDANE

High up in the mountains the day is dark and cold. Raining a thick, silent rain, the road is muddy, and the wet earth cakes the motorcycle and my legs. Keeping the bitter weather away, I'm singing. With no warning I hit an unmarked switchback and I'm in the air, roadless, previewing the scene of the accident. I land soundlessly in a lake, with the motorcycle between my legs, the water up to my seat, and the engine still running. Engaging the clutch, I inch forward slowly, waves splashing at my waist.

The wake of my movement ripples against the waves. I'm up the embankment and out of the lake, smooth and quick as a shortcut. But the surprise of it sucks me in. Standing motionless at the edge of the lake, the engine whining, I gaze back across the water that is already returning to stillness. The landscape withdraws, sound dampens, and my sight goes shallow.

I set up camp early in the evening. I'm exhausted and vulnerable. I slide into my tent and feel the day's events dispelling from my body. I ache with the tension of almost being dead. After months traveling outside, vulnerability makes me apprehensive. The tent offers no protection against the wildness I sense around me. For the first time the wildness feels threatening. The noise of the wind wrenching at the slick cloth is violent and loud.

I slumber wakefully, images of the accident precipitating from my half sleep. They come to me like flowers on a table, or sunlight on a windowsill. The accident is just an ordinary event fitting seamlessly into the flow of minutes, hours, days.

But I wait. I wait for a ripple, a tiny tear in the mundane. Wait for that opening through which I can slip, that opening bringing me back to subtle, back to humorous. Bringing me back to what I knew.

ROADS LACK DEDICATION

A path. Drive it, walk it, take it to be somewhere. When you're on a path, you're in the place you're in. There's no distinction between the path and the place itself. The path's a minor clearing, a simple parting. But it's a complex thing because it takes the shape of each place, intimately. A path in sand is more sand, sometimes rustled up; a path in earth is compressed earth; a path in stone is a slight leveling of the stones. Sometimes a path is nothing but an indication on a map, the reality having been blown or washed away. The path goes through places usually the most beautiful way so that when you're on this way you can see beautiful things. Sometimes the path wanders about and you wander about with it.

Direction lends order and tempo. When you move along, everything on the move is part of the path, as well as the way to another place. The path can be only where it is and nowhere else: the path is dedicated.

A road is not a place. A road is a platonic surface homogenizing with velocity and predictability. A road takes you from here to there and what's in between is merely in between. On the road, the thing is to get there. The road clears everything out of the way, gets you there no nonsense. You're nowhere but on the road when you're on a road; you're not where it is. It's the nature of the road, it takes you out of the place you're in and makes the road the where you are. It's the difference in form between the road and the place it's in; it's the potential for speed and the linear inclination. Sometimes the road is a vector, in Texas or on Skeiðarársandur, for example.

Until 1985 or so, Iceland had nothing but a countrywide network of paths, which if you were committed enough, mostly got you where you were going in time and without ever removing you from the landscape. But now Iceland's largely been converted to roads and you're rarely where you are when you're on them. Roads lack dedication.

LITTLE SHOWERS

I arrive late to a darkened hotel. The illuminated doorbell brings the receptionist who shows me in and with no other formality hands me the key to a room upstairs.

The building is a thirties era affair built in the 1950s or early 1960s. Historic character, various details here and there offer Deco-ish flavor and subtlety. There are even structurally unnecessary bits rare in rural Icelandic building. Doubled half-round lips of concrete softly articulate the windows and entryway. Clerestories broken into finely proportioned panes of glass run vertically above the entrance and horizontally under the eaves, wrapping lightly around each corner of the building. A boxed spiral stairwell with rounded terrazzo steps gracefully rises around the main entrance. Long, generous halls, incandescent table lamps, and seating arrangements create little intimacies in unbroken stretches of space. Except for these night lights spotting the halls, the place feels empty.

Even though the region is isolated and sparsely populated, the building is big, built to accommodate lots of people. Uncluttered black stone floors emphasize institutional scale. The hotel is a school during the year. It draws younger children from the homes of farmers living throughout the area. In the summer months when school is not in session a sparsity of guests leaves the rooms mostly vacant. But when there are guests, you hear everything; a door closing at the other end of the hotel reverberates into the night.

I'm too dirty to sleep. I need a shower. At this late hour the hotel is shut down and the staff is gone. Wandering around barefoot, I find the swimming pool.

I open the door to a cavernous room. The light from the hall slices a wedge through the interior. Reflections punctuate the tiled walls and the chrome fixtures lining them. The intermittent dripping of water on the ceramic floor resonates in the darkness. I grope until I find the faucets.

The pressure is strong, the water soothing and hot, and with the usual smell of sulfur. But the showers are short and the water hits at waist level. I'm too tired to stoop. So, I slump on the cold tile floor; the water rinses over me; gurgles, sucks, echoes, drains beneath.

FALLING TREES MAKE SOUND

The road is the shoreline. The tide is out and I'm on my way. To the north, the fjord. To the south, the mountains. Cloud cover lies heavy and low, and a diffuse gray light dims the landscape. Old farms stand along the base of the mountains. All of them are abandoned.

A parallel spiritual world is said to inhabit the island. But not just a romantic idyll of goodness. And regardless of who we are or what we do, the landscape is something to be reckoned with, something to be acknowledged. Mostly the spirits are easy and inviting but some aren't. And predictably the stories about the bad spirits are the most popular. And they are the ones whose presence I sense here. It's happened to me before. The feeling of unwelcome. Arriving and sensing that it's best to move on, no matter the beauty. Best to move on because the lure of the beauty is confusing, even threatening in the gray light.

The shoreline abruptly cuts out toward the ocean where a building appears in the distance. Two short stories high, a structure shaped in the likeness of the Taj Mahal stands near the ocean. The Taj Mahal has a strong presence for a building of such modest size. Painted long ago, only dull patches of color remain. Large chunks of concrete cracked from the facades and dome lie about in the grass. The sun breaks through the clouds in intermittent bursts. Specular rays of metallic light shine down, giving the building the vividness and clarity of younger things. Mysteriously the rays of light, so clear and precise, direct me toward the building.

In the backyard all the animals of Iceland are stationed. Seals, sheep, cows, ponies, and reindeer are clustered together. In concrete cast long ago, the creatures have acquired a spotty patina of white and orange lichen. Walking around the Taj Mahal toward the seaside, bright with the only patch of sunlight in the sky,

a faint sound of humming grows louder as I approach. Turning toward the building, I stop, stock-still. The entire two-story facade is carpeted with flies. Seething and buzzing, the iridescent black surface repulses and unnerves me.

Evening has arrived, the temperature is dropping and the wind is picking up. The tide has come in and the road, now submerged, will only come back when the tide goes out. In the meantime, I've found a soft grassy spot near the shore and pitch my tent. The ocean waves roll gently just below. The lapping sound of the water accompanies me into sleep. In my dream trees are falling. They are falling and, even unheard, I hear their sound.

VERNE'S JOURNEY

I was looking for the entrance to the center of the earth. I knew I had the general location right but there were so many possibilities out here. Turf steps at the end of the land lead me down into the earth, almost underneath the sea. They take me to a black room, a stone well filled with prized but stagnant fresh water. Along the coast the cliffs are pocked with holes. Each one lined with basalt columns dropping straight down to unseen depths. I can hear the sea rushing in and out down below. And in one of the lava fields a peculiar rock formation opens abruptly into a darkness that is precisely the absence of light.

Verne discovered the entrance to the earth here, back in 1864. As I searched for that entrance it became clear: all those episodes of geologic wonder he described on his way to the center are scattered about here in plain sight. A field of bright red craters runs out to sea. One of them, with its wall broken through, performs as an amphitheater, boosting sound and as a ventriloquist throwing the sounds of the surf into its bowl. The first time I entered the crater I turned to run out because the suddenly very loud ocean, I thought, was flooding in.

From the fields of lava and the ocean floor enormous basalt formations rise. They stand unattached and alone dominating the landscape around them. Caves of once-molten rock tunnel for miles from one part of the peninsula to another; they are mazes filled with false starts, dead ends, and unknown exits. And there are stories recorded in the old almanacs stating that up near the glacier, an unknown force, a negative energy, depletes travelers and their ponies. Unable to go on, they die of exposure. And often, because this is a small peninsula way out in the Atlantic Ocean, turbulent winds lift the horizon from the sea and the ocean mimics Verne's awesome vision of the center of the earth, that of an ocean with no horizon.

Unlike the Danish cartographers who drew and redrew the shape of the island, Verne never came to Iceland. He used those maps to imagine a place he'd never been; he described a reality he never experienced. Even so, his fiction is often an accurate depiction of this place. But the entrance is no fiction. It's no act of imagination to believe that the journey to the center of the earth begins here.

THE PROBABILITY OF ROUND ROCKS

With my binoculars I survey the shore below. I see a simple rock-covered beach. But an oddness about the rocks, a peculiarity about the shadows, draws my gaze. As I linger things become clear. They're not odd, they're not peculiar, just highly improbable: the rocks are *round*. This is a place where forces come together in rare balance, forming ball-shaped rocks—like the eggs of screech owls.

As I walk down among the rocks their roundness confirms me. Even as I stand among them they are a fantasy of perfect things: a litter of perfection in a place like any other.

SPECIAL EFFECTS

Pressed by the darkening skies, I'm looking for a place to settle for the night. I've been on the road hitching and walking for days. Here now in a clearing near the ocean thousands of arctic terns flutter in and out of the tall grass. I sense the vast population that is nestled down on the sand, still invisible to me. Slowly, slowly, the birds' movements become agitated. Their shrieking cries become louder. They start swooping up and down and up over the field. The tall grasses spread and flatten under their wings. I can see the dark clouds forming as the birds mass. Angry shrill sounds invade the windy silence. The cries merge into an overwhelming loudness, a hideous screeching. I'm running toward the road when a single tern separates from the trembling cloud the flock has formed above me. Glancing up, I see the tern hovering, holding itself still overhead. Abruptly it dives straight down.

I run toward a small road leading out to sea. The road becomes a path and eventually I am on a beach. The blackness of it is dazzling. And the foaming white of the surf makes the sand look even blacker. The beach spreads out before me filling the horizon, the stillness of the black in answer to the spindrift and changing light above. Off in the distance I can see the cliffs of Dyrhólaey filtered through the haze. Massive broken-edged cliffs rise from the water, a vision, a two-dimensional backdrop always far away.

Dyrhólaey is a simple place, and in its simplicity, demanding, even insistent on what's not here. So insistent it provokes thoughts about all that's absent. I start importing things. I begin with palm trees. My obsession populates the beach with small stands of palms scattered here and there. Palm trees are an arbitrary choice, but at present they are the most compelling absence.

This is a ruthless intelligence, simple and inescapable, one that obliterates all

that's before me and replaces it with whatever I desire. It's a compulsive mirage, a psychological optic. Not only am I not in the place I am, I'm nowhere else either.

LÓA AND LÓA

I arrive in a small town in the West Fjords. A large population of ravens, playful and raucous, dominates the shore. I'm sitting on my motorcycle watching them, watching the light change over the fjord beyond. A woman comes out of a sweet little corrugated tin house and walks over to me. Her name is Lóa. (Lóa is also the name for the golden plover, a bird that makes delicate, elusive sounds.) She asks if I'm from America, her son is living there. She puts her hand on my shoulder. I take it as a sign, I decide to stay. This is the place. I pitch my tent in a small field, apparently the ravens' stomping ground. I'm thinking they'll be entertaining neighbors.

The next day I'm hired by a Danish fisherman to salt and stack codfish fillets: close packed walls as tall as me and as long as the factory building. The fisherman, who likes speaking in English, tells me stories about the West Fjords. About how there were no interconnecting roads between fjords until the early sixties. And until then, if you wanted to go to another fjord you'd walk, wearing catfish-skin shoes. Distance was measured between them in how many catfish-skin shoes were needed to get there.

My second job is the one nobody else wants. Outfitted in a yellow rain parka, hood up and pulled tight, I worked the "shower job." Standing on top of a fish-processing machine, I am responsible for lining up the freshly decapitated cods. Spit out by the machine the headless fish skidded down the steel gutter directly into my station, the eyeballs gathering in the corners.

At the station next to mine there is an older woman who reminds me of Lóa. It's the smile. Like Lóa, she's in her early eighties. After a few days of working, the woman with the smile who only speaks Icelandic invites me back to her home for the 3:30 afternoon break. We walk in silence to her modern concrete home on the

far side of town, away from the water. From the refrigerator she takes herring and tinned fish, makes tea and puts out crackers. A large clock on the wall ticks. We have fifteen minutes. We smile at each other. I listen to the clock. We exchange more smiles. I'm beginning to feel relaxed.

Before I left the fjord I learned that my new friend and Lóa are sisters, twins in fact, though estranged for many years. There was something serendipitous in it, in meeting both of them like that. One thing was the appearance, but the spirit too?

The ravens are especially stimulating here and so is the sky. At night I read Edgar Allan Poe. Or if I leave work late I get on my motorcycle and drive to the next fjord just north of here. I sit in a little hot pot, mesmerized by the heat and exhaustion, and watch the sky.

They have special clouds up here. People say these particular clouds are unique to Iceland. I believe them. They look like flying saucers. They only occur in the north.

WEATHER IS NATIONAL SPORT

I want to talk about the weather, island weather and Iceland's weather in particular because it's an extreme situation that implicates all other weathers —Weather is matter—Weather is history politics religion psychology culture— Weather is the empirical and the circumstantial—Weather is common sense —Weather is entertainment and killer and national sport less strategic but more spectacular than chess—I'm for the weather but some are against it—And anyway in all ways weather is the measure—It accounts for what you can and can't see here, what you can and can't do here—And when and for how long— It's the formative factor in the shape of all things—It governs the government and regulates the spirit—There's nothing here that isn't relative to it even the roads bend to it—When an island's this far out in the ocean it's not much more than an anonymous object upon which the weather performs—Usually the weather makes things less anonymous, more alive but not always, there are wastelands looking toxic, too.

Here on the southwest coast the winds frequently get violent. They come straight out of Florida, just off the Keys I like to imagine. Out of the windows, narrow slits fit against this turbulent atmosphere, I can see dark clouds, heavy with water, rushing up the coast from the south. The winds are pulling hard and they hit the lighthouse with concussive impact. As I look to the north, I see present conditions departing. A calm, quiet air bathed in rich warm light drifts slowly northward. The sun is descending in a clear, still sky, and thin tufts of cloud cast blue shadows on the ground.

I'm on the cusp of climactic change: a stormy future about to arrive, and a quiet, picturesque present, slowly departing. Opposite windows let onto these

wholly different atmospheres; there's a turmoil of change out there, constant and radical.

The rains come, the temperature falls rapidly and as evening wears on, wind-blown sleet begins icing the windows noisily. Blunt periodic blows punctuate the evening. By morning the windows are sealed in ice.

Out on the bluff, I can see it is a bluff no longer, but an island. The night rains and sleet flooded the beach. Days go by and I become more and more anxious. The recently developed island condition remains unchanged. The gray light reflecting off the water surrounding me makes no distinction between old and new. It all looks the same, the same salt water lapping at this former bluff. These aren't quiet laps either, they're turbulent and lashed with foam as they define new coastline.

An island island is not a simple redundancy. It's a compounding of isolation; each degree of island asserts a deeper and greater measure of solitude and distance.

ANATOMY AND GEOGRAPHY

The interior of Iceland is a desert of ice and ash. The desert is complete without living things; it's occupied with simple duration. Staying here means having intimate relations with the weather. I exist. I live with the forces that define it. But I remain outside of it even when I'm in the heart of it. The desert is what it is and no more. Occasional bits of litter blowing in from other places lessen the condition of solitude and wholeness. Litter is comfort here.

There are a finite number of things in the desert: the space, the ash, and the rocks; the light, the weather, and the ice. There are other things as well, but only a few. Some of them aren't even here, but you can see them from here and differently than from any other place. I saw the moon for the first time from here—it was a large piece of the sky, a terrain—looming and white.

I use the desert as measure, as lucid reflection. It gives nothing.

What I take from the desert is who I am more precisely.

Having limitations defined this clearly is identification. The desert allows nearness to the unknown. And it forces you to travel farther from the known. It finds direction and place that never become familiar.

The desert's a place ineluctable, a constitutional future—unknown and necessary. This is inner geography.

INDOOR WATER

Water drips from the ceiling into the pool. Each drop echoes loud and resonant in the concrete chamber. The water is hot, steam fills the air, condensing on the walls and ceiling. Yellow-green mold grows copiously, encouraged by the vapors of the naturally hot water. The wet room amplifies the sound of my body as I float in the water. My breathing gets louder and louder. I hear it reflected from every part of the room. It emanates from the corners, the ceiling, the windows.

The building is breathing, breathing my breath. Concrete fills my view. The granules of cement grow larger as my vision telescopes, in imitation of my respiration. The room is teeming with the loudness of my breath, I panic. A final kick fills the air with the crisp smack of water. I pull myself out and return this room to its essential vacancy.

PRONOUNS DETAIN ME

Out of touch, lazing about on a grassy shore overlooking the bay outside of Reykjavík. A kind of Sunday but I don't know what day it is. The sun is setting in a cloudless sky and everything is bathed in that bright night light here. Too beautiful, too extraordinary for me. Beauty bores me, intention overwhelms me. My mind slides helplessly here and there. I'm angry.

The sun glistens on the water. Each spark of brightness finds a place in my gaze. A whole world of sparkling undulations lay before me. The bay is large and the water is choppy.

Off in the distance a dark spot on the horizon moves toward me. A kayak, oar switching rhythmically over and back, over and back. The movement is smooth and slow, fixing my attention. He's wearing a wetsuit, it's still only May. His arms are large and muscular and the back-forth movement is full of grace and sensuality.

The kayak heads toward me. Approaching the shore, the oarsman gets out and lands the kayak, dragging it up from the water. As he pulls his wetsuit off, the delicacy of his proportions and the fineness of his skin transfix me. When he takes his cap off the longish hair fails to enlighten me. The fullness of his chest in silhouette provokes no doubt. He is a woman.

Instantly this history of watching is recast as a slow caress, an erotic dream of unexpected fulfillment. The sea becomes an extended sexual event with a climax that attenuates until I am aware, not that it's over, but that it never ended.

I lie back on the grassy shore, grinning. Peering up at the clouds I squint, first the right eye then the left; the sun darts back and forth in the sky. As the sun jumps my anger returns; I want a language without pronouns. I want to come, direct and complete, without pronoun.

BLUFF LIFE

Letting the Sea Lie Before Me

I thought of it as a wager. It was March 1980, and I was on my way back to New York via Keflavík. When the plane landed in Iceland, I spent the forty-five minute interlude walking the tarmac, enjoying the cold, delicious air. Like a child I wondered at the cool clarity of it. That's the moment when it came to me. That's the moment I knew I was going to stay in the lighthouse down at Dyrhólaey.

Dyrhólaey is isolated. By car the lighthouse is an unmarked drive across a black sand beach. I head for the base of the bluff and hope there's a road there. When I find it, the road is a long series of switchbacks rising slowly to the top. From there everything drops away, and the earth's nowhere in particular. This was the Dyrhólaey I visited back in 1975.

By foot I head across the beach to a grassier part of the cliff face. There I find a zigzag sheep trail leading up to the top. Slow going, vertical, but it works.

Two years after imagining it, I took the wager: to live in the lighthouse, on this bluff. To let the sea lie before me.

Action Shots

It's action-packed up here, albeit very slow action, not obvious, not always easy to see—the weather, the birds, the ocean churn: an occasional seal napping on the shore.

I spend the days wandering the bluff. With binoculars I watch grains of sand leveling on the beach. I watch a raven land in reverse, as the wet wind intercepts

and blows her backward. I catch glimpses of birds snatching other birds in flight and many other fugitive incidents of survival.

Night for Day

Cliffs define the bluff three hundred degrees around. Each part is populated with colonies of birds. Dyrhólaey is a city of birds; the cliffs teem with them. But on the ground and shore they're more sparse. On the peninsula-like extensions and the intricate cliff faces there are razorbills, puffins, guillemots, auks, fulmars, kittiwakes, petrels; among the bluff grasses and fields and down on the shore I've seen skua, arctic terns, eider, oystercatchers, ravens, golden plover, whimbrels, and ptarmigan. There are songbirds too, nesting on the ground, and as I walk their songs rise up to me.

May and June is nesting time and eggs cover the cliffs. Every nook and cranny has an egg or two. They are various shades of white, yellow, and light, light blues with occasional brown-spotted ones. Together these eggs and the bright white bird droppings punctuate the deep fog-washed views.

When I approach the cliff, I walk through a quiet inhabited only by the wind. Near the edge, I step through an unseen boundary. Suddenly, the sounds of many many thousands of birds emerge, blending into one thick, discordant roar, an oceanic roar, going on without interruption or end. When I walk through this wall of sound I hear dogs barking, the thrum of heavy traffic, donkeys honking, choirs performing Bach cantatas, machine gun fire, wind whooshing, squeaking swing-sets, tsk-tsking, chalk scratching across blackboards, speeding cars, wind rustling in trees, big machines humming, heavy rain falling, stormy ocean waters dragging rocks from the shore, axles grinding, crowds roaring, people yelling back and forth, squabbling, laughter, mass protest, snoring, lots and lots of sneezing, snorting, gurgling, spitting. . . . This noise is a part of the landscape here, like the bluff itself. It doesn't go away. When I arrive, I become the audience for this geologically scaled performance.

In the early hours of the morning I wander the cliffs observing the nightlife. Night is a whole other world, more active than that of the day, and though the night's not actually dark, things happen as though it is.

I find the puffins again. They had disappeared since my arrival a month ago. Here at four in the morning they are returning in large flocks from a night at sea. They drop down flapping their wings furiously as they land on the grass-covered cliffs, disappearing at once into earthen burrows.

After midnight another performance begins. I stare out the tower window into the twilight darkness below. Up from the sea, birds soundlessly gather on the lawn in the shelter of the lighthouse: eider congregate on one side, the bright white of the males, the quiet browns of the females. Various ducks waddle about solo here and there. Oystercatchers with their orange beaks peck at the earth. A single large white bird, perhaps a gannet, struts about aimlessly. This is an image out of a children's story, with all the familiar roles performed by birds. The semi-darkness flattens the scene and lends a theatrical quality. I watch the secret gathering nightly, waiting for a narrative to unfold.

Out to sea, the sky is full of gray clouds tucked under with a dry warm light. They move along quickly, almost rushing. Orange is the color of night here. And in this bright night I watch an easy dozen boats surreptitiously fishing the ocean. Their bright submerged search-lights disturb the view. Blotches on an otherwise unoccupied horizon.

Even without darkness the night is full of stories.

A NEWARK HERE

One evening last winter I lay outside at a hot water spot, a small lagoon. The water was opaque and a strange acid, baby blue color. It sort of offered comfort but it looked toxic too. The black and rocky shore was encrusted with a mysterious white residue. In the niches where the water was almost still, the waxy deposit thickened into a cake that covered the ground. On the far side of the lagoon the water lapped against the metal piping and smokestacks of a pump station.

Situated in the middle of a lava field, I drove in on a road littered with steam and water pipes and the many little bridges and trenches built over and under it to accommodate them. It was Newark; the place looked and sounded and even smelled like it.

Alone in the lagoon, I lay in this strange almost creamy liquid on a cold, windy night. The blue milk cut a line around my neck and everything submerged in it disappeared completely. My toes peeking out were pink pebbles a few feet away. The wet heat filled the air with fog as I floated about effortlessly. A white cloud mobbed me, lazing about my head.

When I opened my eyes the world was nothing definite, a fuzzy brightness and not much more. But somehow through the fuzz a single wooden picnic table (with attached benches) was still visible. It set me dreaming of my childhood. It was the only bit of hospitality offered.

I couldn't see the pump station, but I could hear it: the ambient noise of general industry, steam venting, and the occasional lap of water against metal. These sounds were the only things definite around me.

This diminution of sense calms and relaxes. I float. I take a holiday: not to a place, and not in time; I take a holiday from the draw of awareness, from the friction of seeing and knowing.

ISLAND AND LABYRINTH

Big enough to get lost on; small enough to find yourself. That's how to use this island. I come here to place myself in the world. Iceland is a verb and its action is to center.

There's a labyrinth not far from the entrance to the center of the earth. I've never actually seen it but its existence here is indisputable. The possibility of obtaining the innermost point of the earth is the definitive centering. And Iceland is the definitive point of departure.

The weather or even the roads here, which are more like paths, are labyrinths. Things that lead a way, forcing you out into the world and more in upon yourself. What this island is defines you. As long as you don't stop there's no getting lost, though there is the illusion. The labyrinth razes all distinction. Disorientation comes quickly. Your sense of place breaks down. Your relation to the world beyond becomes tenuous. Go on long enough and doubt may isolate you. Go on long enough and clarity will become you.

WHERE THE EARTH IS HOT

Dig a hole in the ground. Bake the bread where the earth is hot. A six-month solitary journey living in a tent is a long search for warmth. I move from place to place staying or staying longer where the earth is hot, where hot water gathers at the surface. There's no fire here, nothing to burn, only the fire of the earth when volcanoes erupt or the crust splits open. And because I grew up with fire its absence here makes the cold intolerable. The midnight sun offers the image but withholds the comfort. The deep colored light looks hot but is cold.

I am hot water hopping. I go from pool to pool regulating my spirit. I'm drawn for miles by the steaming vapors wafting and rising softly from the ground. In the water, I lie against the cold, wet air. This water hot from the earth boils out across the island. It's a natural shelter. When I'm in the hot water, I'm inside, I'm protected.

Mostly the heat brings boiling mud, spitting earth, or venting steam. A field of holes in the dirt each one making a unique sound, giving off its own odor and fog. Hot air rushes out here, mud pops subterranean there. It's hot and I'm cold. I see the steam rising through the freezing air. But I can't get close enough. I am cold and this heat is cold too.

YOUTH AND GEOMETRY

1

I'm traveling the north road of the West Fjords, east out of Ísafjörður, the most isolated inhabited area of Iceland. Abandoned farms are scattered throughout. The oldest ones, beyond ruins, leave a delicate and beautiful trace: blooming yellow flowers in once fertile fields.

Here are buildings of wood, so rare on the island only traces remain. But the remains amuse; a structure to dry fish is a house on stilts. And stonework, a unique, finely set stone wall runs along the sea, a few slow kilometers. Vibrant patches of bright orange and white lichen cover the wall.

Traces of turf buildings on the outskirts of the villages form rustic borders to the inner fjords. Beyond the turf remains are the ruins of abandoned houses gaping pink and blue concrete interiors. Contemporary homes stand singly or efficiently in small clusters.

This almost unanimous abandonment infuses the atmosphere with a menacing aspect. It's a ghost town going on for miles with no center. Broken-down docks lead out to abandoned ships. Sunken iron boats in defunct harbors are visible at low tide. It's surprising and strange to find farms still inhabited here.

But it's mainly the rocks that draw attention, like another less familiar architecture. Entropy is the *source* of things here. The stone breaks down *and* takes shape. Rock formations crack into thousands of parallel fragments and remain whole. Large fields of rock break into patterns of textile-like regularity, and mountains record each successive lava flow as a single step. They pile up and up into perfect pyramids of organic origin.

But mostly the rocks are young. Fresh fragments form sharp rubble, each piece

crisp and intricate with definition. The rubble collects at the base of mountains, falling together like paving, and settling into straight and notably vertical angles of repose.

Polygonal crystals of basalt form close-packed columns. Over here the basalt cooled into a plain of tiles, simple and neat. Over there they're fine and organized like magnetized iron shavings. And right here the crystals are large, forming the hard, upper crust of a plateau. At the base of the plateau not debris, but ruins.

A tunnel, one of only three in the entire country, cuts through a mountain of basalt. The columns are clumped into large bundles, thrown together from every direction. The walls of the tunnel are made of these unfettered geometries, perfect polyhedra fit together as in the three-dimensional tiling of an interior.

The asymmetries have the deliberation of symmetries. The symmetries have the probability and abandon of asymmetries.

2

Now in the south, things happen with a strong feeling of artifice, too, albeit a fake artifice. Lined up along the horizon are discrete chapters of geologic events. They form a sequence from edge to edge. And they're arranged from west to east; when direction is reversed, a completely different narrative unfolds.

East to the black sands. They're flat, going on for miles without vegetation.

Further east the grasses begin to appear. In September they grow sparsely in the black earth forming separate fields of mono and dichromatic arrangements: red—red and green—yellow and green—red—green—yellow and red—green—yellow and pink—yellow—green.

The sands stop.

A plain of lava begins. Bulbous, unruly shapes are covered with the thick gray-green moss of young lava. The plain stops in a meniscus, another begins: smoother and younger than the previous one, it lies on top like a spill of water on a table.

Short, stubbly moss mimics the ripples of the original molten flow. Where the lava breaks apart to the black earth underneath a field of cones begins. Each cone is blanketed in close-cropped grass and tipped with an exposed chunk of lava. The accumulation of bird droppings over the years transforms these tips into the erect nipples of feminine breasts. The cropped-grass look and the enigmatic organization of the mounds suggest a playing field for an unknown game.

Soon the mounds flatten out, the grass becomes sparser and another flat expanse of ash begins. On this plain an occasional large boulder, an erratic, appears.

The boulders are sandblasted smooth, giving the look of something plastic and formed. The consistency of spacing between them is striking, as though each was positioned in its specific location in this duneless desert.

A single episode is complete with its own origin and history. But sequential relation gives definition and scale to each, leading on to a larger narrative: the narrative of the unrelated and the near and neighboring producing a single indivisible terrain. This terrain lies out here: young, even fresh, some of it as fresh as two hundred years.

SLEEP: ROTATION METHOD

I come up through a hatch in the floor. Now I'm in the tower with the light. I spent a lot of time with the light. It's not simply a fixture here, but a presence and a regulating force. It's not simply in the building, the light inhabits and animates it.

The lamp is hundreds of pieces and many tons of glass prisms fixed into a four-sided bronze head. They're arranged in concentric circles on each face and each face describes a large centered eye. Each prism is a compound curve of polished, bottle-green glass. Each uniquely shaped and dedicated to its location.

When the sun goes down the light automatically turns on, rotating through the darkness. When I'm in the room, watching it start up, I'm watching an insentient thing motivated by an unseen force. When I'm downstairs its presence takes on mythic proportions: a massive head form with four faces and one eye in each face, four Cyclopes arranged in a circle looking outward.

The first nightfall in the lighthouse automatically initiates the light's rotation. The massive tonnage grinds overhead infusing the building of half-meter-thick concrete with a ticklish vibration. Outside, swatches of light sweep across the bluff at short, regular intervals. Watching from the window it's a constant coming bright in the dark, not really a flashing. When the atmosphere is foggy or thick the whole outside goes white as the light reflects and names each particle in the air. Lying in the darkness, eyes closed, the rapid, brief brightness twitches at my lids.

A clear and certain sleep follows. In the early morning the light shuts off and I awaken. After a few days of living in this light-inhabited building I am peculiarly dependent on its regulation. The light has become a lyric instrument through which organic time has fallen away.

I sleep and wake by the light. Toward the middle of June, the days grow longer and the nights get briefer. By the end of June, the night has ceased altogether and so has the light. I become an insomniac, unsettled by the interminable silence, the heavy stillness of the light.

WHEN DICKINSON SHUT HER EYES

I Go to Iceland—

Recently I was reading the letters of Emily Dickinson. I began wondering about travel and Iceland too, wondering about the insistence of my returns here, about their necessity and the migratory regularity of them.

I began to wonder about travel altogether, about the how and the what of it. Travel isn't so simple as a car or a train, or as nameable as a place. I thought about Emily Dickinson's travels. From the first letters she wrote she told her correspondents she didn't go out, she didn't want to go out, and that she would not come to visit them. Dickinson stayed home, insistently. Locking herself into her upstairs room, she invented another form of travel and went places.

Dickinson's invention was multiplication, herself and empirical reach: everything that could be felt, heard, seen or smelled, everything perceptible, everything discernible from 280 Main Street, Amherst, Massachusetts. Perceptible includes the library; somehow Dickinson used the library as an empirical source, somehow, she learned to consume its contents sensorially. Her library was not a source of acquired knowledge, not a tool of the intellect. Her library was simply another perceptible thing becoming another entrance, confirmation of all she sensed in the world. Even her poems about God and being dead are eyewitness.

Sequestered from the world, knowing that going out into it hampered her ability to invent it, Dickinson stayed home except for two summer trips to Cambridge as a child and one to Washington later in life. Dickinson stayed home when Ralph Waldo Emerson visited her brother next door. Her business was circumference.

In her verse Dickinson spoke of Vesuvius at home. In her letters she said she traveled when she closed her eyes, and that she went to sleep as though it were a country. In her room alone, she said, was freedom. Here she wrote one thousand seven hundred and seventy-five poems. Dickinson shut her eyes and went places this world never was.

For the time being, Dickinson is here with me—in Iceland. For someone who stayed home she fits naturally into this distant and necessary place. Her writing is an equivalent of this unique island; Dickinson invented a syntax out of herself, and Iceland did, too—volcanoes do. Dickinson stayed home to get at the world. But home is an island like this one. And I come to this island to get at the very center of the world.

PASTORAL AND CAVE

The evening is mild. I've arrived in a peaceful, green valley, pastoral to the bone. To the north and west are the lava fields and Surtshellir, perhaps the island's largest cave. For some time I have imagined its all black interior intensified by the natural darkness of underground places. I've been drawn to this cave for years, one of the few things I knew about the island before I came here. Surtshellir is a magnet for me, as all caves are. I am drawn, almost perversely to their disturbing, even threatening presence.

The cave goes on for miles, I've read, with complex rock formations, mostly unknown, since it is still largely unexplored. If I actually find the entrance, I'll want to go in, to go farther into this unknown place. But it's too late now. For the time being the weather is with me, the air is dry and still: a rare calm.

Dinner, a wander about, and I've settled into my tent. It's already approaching midnight when I slip into my sleeping bag, ear to the earth. Footsteps in the distance—faint at first, become firm and heavy. I hear the ground compressing and intermittently, a crunching sound.

Suddenly loud, the sounds are upon me. Nuzzling in the door of my tent, snorting and kicking the earth two young Icelandic ponies have arrived. They have come to inspect these foreign objects: a green tent, a red motorcycle, me. They move about lazily tearing at the grass. For a short while we watch each other and then, still chewing, they saunter off. Sleep comes gradually. I dream-see—the warm-colored light of the midnight sun, the quiet valley, the footfall of the ponies, the calm of the still night air.

Deeper into the twilight night the stillness is switched off. I awaken abruptly. Violent, loud winds overwhelm me as they whip and tear at the tent. Arriving from three directions, they are inescapable. The mad winds take my sleep and

prevent me from departing. An enforced vigil begins. I sit at the entrance and watch. Outside I see my motorcycle, blown down, lying in the dirt.

Rain comes heavy and loud. It pelts the tent horizontally. From the entrance I can see a sheepfold across the field. It'll be wet, but it will be quiet out there.

I lay back against the wet grassy walls of the fold sheltered from the winds. Water runs over everything, a temporary stream. I relax into it like wild vegetation.

The tent is bowing and bending in the wind. Under the sky, a dark gray monolith, I wait. The wet, heavy air cramps and isolates me. I'm already in the cave and I haven't even found the entrance.

THE FLATS (AFTER WILLIAM MORRIS)

Driving across fields of black ash, travel is slow going, tedious, unending. Sand drifts reduce the road to wooden markers, not even the ruts of previous passage remain.

Looking to the south I can sense the presence of the ocean although I can't see it. If the water rose up slightly, barely an inch or two, the flats would flood instantly. It's a thought that makes this passage intimidating. When the wind kicks up it whips the sand at everything. I have seen cars with their paint blasted off and the windows frosted over.

Looking north, all I can see is the endless expanse of the flats. But I know that there's a glacier out there and the headlands, the coastline not too long ago. William Morris went through here in the late nineteenth century on horseback. He rode up along the headlands because there weren't any ash flats then, they were still submerged. He observed the streams and rivers that dropped from the cliffs to the sea. He watched as the violent winds reversed the water's fall and blew the glistening streams back up over the cliff edge, spindrift filling the air with rainbows.

Once these were waterfalls only visible from the sea. As the glaciers continued melting, after Morris's sojourn, the land rose up a few inches and the flats appeared. The ocean receded miles and the majestic route of the waterfalls moved inland. Now they fall to the flats in light, dense rains forming idyllic clear-water lakes.

I've driven this passage many times since 1975. It always brings me the same feeling of trepidation: that I'd lose sight of the poorly marked road, or that the sea would flood in on me, or the wind-stirred sands would hide the way.

In the late eighties a road was paved across. A road was built a couple meters up off the flats. The black pavement formed a subtle supplement to the scene.

But still the flats retreated, becoming no more than definition for an unbroken horizon.

You can take this black landscape at one hundred miles an hour now; drive it straight out like the "breathless line" once described by Euclid. You can take the flats and never even notice the presence of the ocean, the sands, or the glacier. Never even notice the lone flower or boulder. Never even notice.

CROSSING A FIELD I REMEMBER

The grasses rustle quietly in the warm morning light as I cross the field. The ground is swampy and wet. I watch the sunlight glinting in the sedge and slowly, awkwardly I step from hummock to hummock.

When I look up Eudora Welty is coming across the field. Even though she's far away I can see her silver-flaxen colored hair in the sun. She walks slowly in the bright, early light, her figure casting a long easy shadow.

I remember her quiet smile and her strong clear voice when she visited school. That was sixteen years ago. Standing on the stage of the lecture hall far away, she read from a story she wrote. Someone was crossing a field. A small shadow in the yellow grass getting larger as it approached. The cool, breezy air rippling through the grass, and the warm, bright light raking the field.

I CAN'T SEE THE ARCTIC CIRCLE FROM HERE

The Arctic Circle is geometry in the Arctic Ocean. It mimics the shape of the planet. I'm approaching the Circle now, a few miles more and it will be visible. Circles aren't usually hard to see and mostly they all look the same except some are larger than others. The Circle is out there in plain sight on the water. This far north nothing obstructs the view. The ocean opens an enormous, unbroken expanse of horizon up here, big enough that there won't be any problem seeing an arc of the world. And I want to see the arc. I want to see the shape of things from among the things themselves.

Since I first saw the Arctic Circle in geography class years ago, I was touched by how perfectly its entire existence coincided with that of the globes. I knew the Circle was real, that it was no mere mapping device, since its synchronous relation to the earth was too unlikely.

If the Arctic Circle were an ironic form it would simply be visible. Visible but imperceptible, camouflaged by its own perfect mimicry. The Circle would be there, like the ocean but never present to the eye.

It's the night side of morning. The sun sits on the horizon. The raking light gives each pebble in the road the large dense shadow of a rock. I'm dodging these rocks and rock shadows as I drive along, unable to distinguish their actual size. By seven I've arrived at the sea. The sun picks itself off the horizon and the indecipherable glow begins to dissipate.

This road goes right up to the Arctic Circle, almost to the top of the planet. The road is just about tangent to the Circle. And I know if the Arctic Circle is just about tangent to something then it must be something. I pull over as I approach the northernmost point and settle down to look.

After staring out at the ocean for some time I notice that everything out

there coincides precisely with the earth's surface, making it extremely difficult to distinguish the Arctic Circle. At the far right and left of the view the ocean gradually and symmetrically drops off and out of sight. It gets darker farther out, as any arc would. But the curvature is so subtle it appears flat. If I didn't already know the earth was curved, I never would have seen the arc at all.

A diffuse whiteness lifts off the surface, making it less a thing and more a part of other things: a part of the ocean and a part of the sky and even a part of the weather. Unaffected by the growing lateness of the day the sun remains high. Slowly a surround of distant specks and various other celestial bodies becomes visible. The emerging multitude reveals its light without shedding it. But I continue staring out—believing it's only a matter of time before the subtleties of the view reveal themselves and the Circle becomes the discrete, perceptible thing that it is.

A FRANCHISE OF RAINBOWS

The entrance to the center of the earth is to my left. It's the volcano Snæfellsjökull that stands far out in the Atlantic Ocean at the end of a peninsula. From somewhere out in the vast fetch between Miami and Reykjavík ferocious winds are generated. By the time they reach this place they're criminal.

Then there's the glacier Snæfellsjökull. It covers the volcano and has obstructed the entrance for centuries. The atmosphere is laden with humidity softening and brightening the views. As I approach the summit a rainbow appears. With all the spectral colors it's no simple sampler. With exquisite distinction, each color forms a stratum in the arch. Both ends of the rainbow are anchored in dense knots of fog. And because the ground itself is hardly visible it's easy to believe that this rainbow goes full circle. Passing through it I emerge from the mountain's shelter. Violent winds smack at the car. Reaching sea level, I watch as the winds whip the water up and the ocean foams into the air, erasing the horizon.

While looking at the view another rainbow appears, evanescent, barely perceptible. It wafts back and forth between visibility and nonexistence.

Throughout my travel I see many of these luminous arches. Mostly they are solo but on rare occasions there are more. Once, three rainbows aligned on a plain. I passed under them as through a tunnel of light.

Rainbows occur frequently here, like a franchise offering the sublime. It's a sublime that's lost its hold on brevity and improbability; a beauty and perfection that enter the world wanton and probable.

WALLACE STEVENS'S ICE

In 1975 this was an unoccupied landscape. Unoccupied except for the lake in front of me, full of icebergs. I was an intrusion. I was unnecessary.

The lake is unique. For one thing, it is surprisingly close to the ocean; so close I wonder if the water is still fresh. A narrow dirt road runs between them, dropping down to cross the suspension bridge that spans the river of melting ice. The ocean is a shallow incline from horizontal but the lake goes down, deep down, over three hundred feet. And that depth has a strong presence, a dimension unseen but palpable. Icebergs roam about without appearing to move—a still life in action. As the bergs drift toward the ocean at the near end of the lake, they pick up a little speed, riding the water in slow motion beneath the cables and the bridge and out to sea.

The water is cold, so cold it affects sound, raising the register and imparting a jagged and edgy quality. The cold affects the water too. It looks and behaves differently, like it's thinner, almost another substance. The cold dominates.

Blue is everywhere. All the whites are blue. The icebergs are blue, pale blue. The distance is blue. The sky is blue. The shadows are also blue. On the far side of the lake, the glacier comes down to the shore and an ice ramp runs into the unbelievably bright aqua blue water. And then the atmosphere. It's not blue, but filled with the unidentifiable color of a sun that won't set.

Noises, indecipherable, come from across the lake: high-pitched, shrieking, hysterical-sounding to my ignorant urban ears. Birds crying? Mating? Angry birds too far away to see? I feel uneasy, even scared. I try to imagine the source, but can't think of another living thing. Something mechanical, but what? I could not find a connection between the view and the sounds. Though I sensed the likeness to sounds of glass cracking or breaking. But there was no glass. There was nothing like glass here.

Everything is visible in this place, it's sparse and simple too, almost empty. Even so the origin of the sounds remains hidden. And the still-life goes on being still and changing. Just the sharp, screeching noises, at times intense and loud, at other times quiet and articulate and faraway. The tension between the stillness and the noise goes on unsettling and confusing.

I stood there listening. But the sounds?, voices? never gave up their source. There was no beginning to them and they never quite ended. The voices permeated the evening air, becoming a part of the unique and strange ambience of the place.

I wonder out here in the cold and ice. I wonder in the light of the night's day. Out here beneath the stars, in my solitude, in my ignorance. I hear these sounds and am awed:

> I saw how the planets gathered . . .
> I saw how the night came,
> Came striding like the color of the heavy hemlocks.
> I felt afraid.
> And I remembered the cry of the peacocks.*

I think of the sound of the peacocks and of the heavy hemlocks.

* From Wallace Stevens, "Domination of Black," *The Collected Poems of Wallace Stevens* (New York: Alfred Knopf, 1978), p. 8.

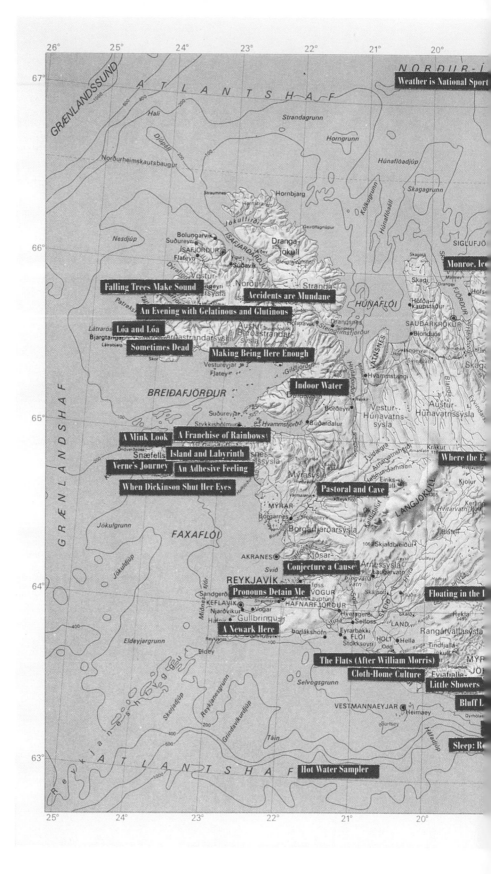

Weather is National Sport

Monroe, Ice

Falling Trees Make Sound

Accidents are Mundane

An Evening with Gelatinous and Glutinous

Lóa and Lóa

Sometimes Dead

Making Being Here Enough

Indoor Water

A Mink Look

A Franchise of Rainbows

Island and Labyrinth

Verne's Journey

An Adhesive Feeling

When Dickinson Shut Her Eyes

Pastoral and Cave

Where the E

Conjecture a Cause

Pronouns Detain Me

Floating in the I

A Newark Here

The Flats (After William Morris)

Cloth-Home Culture

Little Showers

Bluff L

Sleep: R

Hot Water Sampler

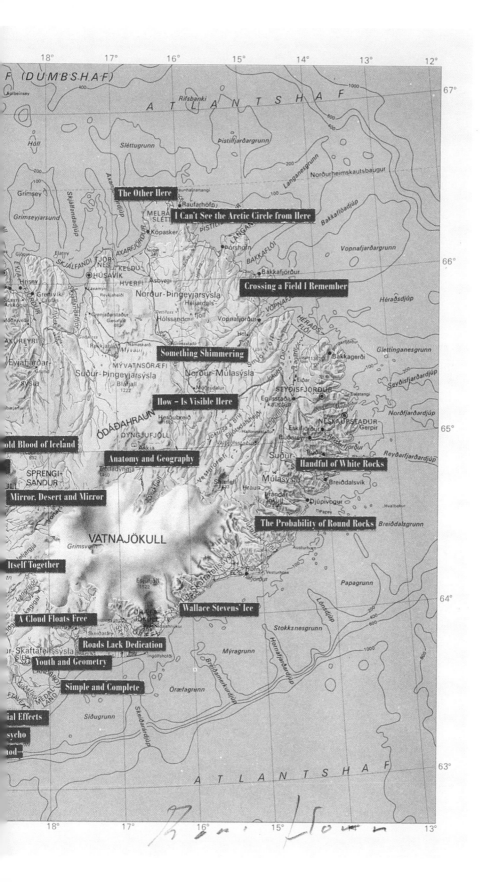

The Other Here

I Can't See the Arctic Circle from Here

Crossing a Field I Remember

Something Shimmering

How – Is Visible Here

old Blood of Iceland

Anatomy and Geography

Handful of White Rocks

Mirror, Desert and Mirror

The Probability of Round Rocks

Itself Together

Wallace Stevens' Ice

A Cloud Floats Free

Roads Lack Dedication

Youth and Geometry

Simple and Complete

ial Effects

sycho

od—

COLLECTED

(1991—2019)

HOT WATER SAMPLER

I've been pool hopping. Searching out geothermal waters around the island. The presence of naturally hot water has inspired a history of structures designed to access it. Often built in remote locations, many have no connection to population centers, not even small ones. This offers the possibility of having the most sensual and spiritual experience imaginable in solitude *and* in wilderness. Without elaborateness or formality, these are the cathedrals of Iceland.

Some are for swimming, bobbing and floating, sky-watching and meditation, others are just big enough to sit in, get warm or cool out. Some are plain concrete basins or small earthen dugouts; some are bowl-shaped rock and concrete constructions sitting on, or dug into, the ground; there are walled areas with black ash bottoms; there are ice caves hollowed out by the presence of heat. And stone caves with hot water gathered from unseen sources. Sometimes surface water comes from multiple origins, cold and hot, pooling in a local depression in the landscape. A few rocks may be placed to help direct and contain the water.

The waters emerge from the ground, in great variety: hot, tepid, carbonated, flat, with the smell of sulfur and with no smell at all. They're pure waters, with a populous chemistry and a transparence that defies all content. Boiling water can be seen emerging directly from the ground. But sometimes it comes out only when a pipe is tapped in. The pipes stick up from the dirt with a spigot attached. It looks like the earth itself could flow out of them when opened, but only water does and under percussive pressure. While it puddles and bubbles in the mud, fog fills the air.

The hot water can show up anywhere. Or it can be piped there. Rising up from deep within the ground, sources are often in uninhabited, hard-to-get-to places. But not always.

- High up in grassy mountain valleys.
- In the intertidal sands of the Atlantic Ocean.
- Far from nowhere.
- Dug into scree-washed fields.
- On the outskirts of town.
- In the middle of town.
- Tucked along a fjord.
- On a road going nowhere.
- On a long walk from here.
- In rock crevices.
- Between tectonic plates.
- In ice caves.
- In lava caves.
- Smack on the coast where a mountain meets the ocean.
- Neighboring geothermal power plants.
- At boarding schools in the middle of nowhere.
- In marshlands.
- In farmers' fields.
- By the road.
- In deserts.
- In lava fields.
- Along rivers.
- In the ocean as overflow from a power plant.

Landmannalaugar was a wholly natural formation, but recently it is accompanied by a wood platform and towel rack. The platform sits just above the wetland grasses and serves as an open-air changing room. The pool forms in a convergence of spring-fed hot water and a stream of ambient temperature water.

South of Reykjavík, **Selljavellir** is an old pool unique in character. Sheltered at the end of a narrow valley, it still gets nasty winds. The basin is concrete on three sides and mountain on the fourth. The bottom is black ash, which casts the water in darkness regardless of the light.

In **Þjórsárdalur** not far from Hekla and nestled alone in a landscape of quiet-colored ash is a pool. The experience unfolds in the approach, as you drive among the desert-like dunes: piles of dark grays, reds, violets, browns, and blacks form a soft edgeless surround. Steam from the overflow of hot water billows in the wind. It is a flag locating the pool from the distance. I recall many solitary after-midnight swims. As you float in the stillness and silence of this soft place,

the weather roams as wildlife above.

In farmland, walking across open fields and neighboring pastures of hay and horses, steam rises over the tall grass in the distance. Here the pool was in the ground in a shallow fold. It was only visible from above: just a simple earthen dugout gathering spring-fed hot water, barely more than a neatly squared hole.

Up in the rural and remote West Fjords, **Mórudalur**, a colorful basin of rough concrete is situated in the intertidal sands of the shore. Two cabanas stand along one side while the others are open to the sea. When the tide comes in, the pool is in the ocean.

On **Barðaströnd** some miles to the south and east along the same coast is a hot pot. A black plastic pipe tapping water from an underground spring leads out from an embankment below the road. The pot is set at the base of a mountain on the shore of a fjord at its most inland and protected point. Here the water, hot and carbonated, drops in freefall directly down into the stonewalled dish. The quiet sound of splashing water diffusing into the big quiet of the island at-large is continuously modulated by the wind. The pot is small, comfortable with two, crowded with more. When the tide comes in the ocean washes at the lip. As with most of Iceland, rainbows frequent the view.

In a neighboring valley, high up the fjord and far from any habitation I found a simple aqua-colored affair set alone in a grassy field at the base of a mountain. As I lay in the pool, I noticed remnants of an old turf settlement scattered about. Just bits and pieces, it was near to completely reclaimed by nature. The deeper greens of the broken-down turf were just visible peeking out here and there from the tall grass.

Much farther north in one of the most isolated locations I had yet traveled to was a structure large enough to be a serious swimming pool. An old boarding school stood nearby. It surprised me, the first time I saw it, so far away and abandoned-looking. With the pool's concrete walls edging toward the ocean, it offers an end-of-the-world scenario: fully exposed to powerful weather from the north; and a top-of-the-world scenario with its expansive views dominated by the horizon.

A recent structure but more or less in the same neighborhood and set in the littoral of a fjord is a hybrid. Too small to swim, but larger than a hot pot. The mundane solitude of it is enough.

And over to the east at **Krossnes**, a prefabricated pool, reminiscent of an over-sized industrial sink, sits right on the sandy shore of the Atlantic, looking like it dropped out of the air not long ago.

Back in 1975 I climbed down into an enormous crack in the earth, **Grjótagjá**. Among the gigantic basalt boulders was a cave with hot water. The source was

deep—the water did not move. The perfect transparency of it was a near match to invisibility. Streaks of sunlight on the still surface confirmed that the water was no illusion. Brilliant reflections were cast everywhere. I went back a few years later but the water was boiling.

And then there's the old pool at **Laugar** just north of Hvammsfjörður. In 1979 I swam in it for the first time. The experience was memorable because it was like swimming in a basement. Water coated the concrete room like sweat on skin. That cold day fog from the hot water filled the interior. I spent some time floating around, watching the mold on the ceiling. Not much going on up there but a lot of it to look at. From my upside-down perspective it was a very green and private garden. From the distance the building looked strange; a doughnut-shaped cloud surrounded it, fed by steam wafting out the windows. Built in the mid-twenties it was the oldest indoor pool on the island. In the village down the road I learned from a shopkeeper that when she was a girl the local farmers and their families would get together, empty the water from the pool and use it as a dance hall.

(1991)

AN ADHESIVE FEELING

I arrived on Snæfellsnes in the darkness of early evening. Stepping in out of gale-force winds, the old hotel was empty. Búðir is poised at the edge of a lava field overlooking the ocean. While the original wood building had been a home, the more recently built flat-roofed extension gave it the look of a motel.

The first thing I noticed was the energy. The energy is clear here. As with the gravity of a smaller planet, there is less resistance.

Up in my room overlooking the glacier a languorous atmosphere settles about me. As if sitting in a hot pot out in the landscape, the wet heat relaxing and tiring; here was the view, the quiet and the comfort, the slow peace, here was the world.

I awoke at nine and had breakfast in the kitchen as the cook listened to Chinese opera and washed dishes. Down the hall the muffled high-register singing and kitchen clatter accompanies me.

The monochrome morning darkness is an extension of night with its simplifying, sheltering energy; it infuses the air and the ocean and even the sound of the waves. Back in the room time starts again, as with a music box upon opening. Out the window the light from my room projects across the lumpy moss-covered landscape. Above the glacier I watch a mellow white light glow, like an earth-bound celestial body.

There's an adhesive feeling to this place, a sense of clinging and subduing. Enervation . . . slow and subtle, permeates the atmosphere as though an act of seduction, an act of submission. The energy goes deep, the attachment is strong.

As time unaccountably continues on, an involuntary urge to linger possesses me. An unearned, though vacuous satiety fills me. Compelled to stay even as the insidious influence of the place depletes me. Snæfellsjökull is draining me, hollowing me out, maybe it will even kill me—a slow, rural death: evacuated from

the inside until I'm no longer really here, just hanging, subsumed by the energy. Or maybe not. Maybe it'll be direct to oblivion, shackled as a zombie to unseen forces beyond me.

(1991)

A MINK LOOK

I was out looking for a well. My map placed it near the lighthouse, right on the shore, nearly under the ocean. It was foggy, not raining, but wet like it was. I was wet, getting wetter traipsing around not finding the well. I didn't know what I was looking for—a hole in the ground, a door in a hillside, earthen steps leading down?

As I was thus occupied, I was surprised by a mink poised on a nub of grass-covered lava. Evidently startled by my presence as well, she was staring at me. I stared back shocked to see the only mammal in Iceland that wasn't a pony, fox, seal, sheep, or cow. As we exchanged stares I noticed that her head was exactly as wide as her neck. And that the neck was perpendicular to both her head and torso. All these parts converged in smooth curves on the mink's blunt brown nose. In a glance I sized up the anatomy of this immigrant animal: a stair profile. Briefly I wondered if she was rabid before wandering off into the grassy boulder-strewn fields. Glancing from rock to rock, I hesitated on the dark spots in the grass. Just as the ground was becoming familiar the mink popped into view and dashed across the green, disappearing into a sleeve-like fold in the ground. As I approached, a slice of darkness opened up revealing a narrow passage. Black boulders lined the faces of the wedge, getting blacker as the passage went tighter into the earth. Except from this one vantage, the entrance is hidden.

From inside, the well itself is a hollow in the darkness. The cavern gathering this prized source of fresh water is lined with carefully worked rocks, tight masonry set to form an impenetrable container. Situated at land's end this dark hollow, unseen from without, is an elusive bubble in the earth.

(1991)

MIRROR, DESERT AND MIRROR

Not Being Here

Here I am. Everywhere I look—north, south, close, and far—I see the same thing. An unusual position to be in, an unusual place too; but is it a place at all? Is it the place that doesn't change or is it boredom—my mind busily extinguishing all difference out there? There's a mirror in boredom and the reflection makes it impossible to distinguish between myself and the place I'm in. Somewhere along in time I started to look the other way. Maybe it was in the beginning. Maybe I started out looking the other way and that's why I can't recognize the place I'm in. Or maybe I just haven't come to a place that draws me out. Maybe I've only been in a place that keeps me seeing in, not out, and as long as I'm in a place like this I may never arrive.

I was walking for some time. It felt like a circle. I was the center. The sameness of it obsessed me. Hard to believe that anything out there could be so uniform. I'd look out from between my partially opened lids, each view framed and calibrated by my lashes. But the lashes made it clear, they were my lashes, they were a part of me. They moved when I moved. They distinguished me, confirming that I was not the place I was in.

Here I am, I'm thinking about something, I'm thinking about something not here, about looking slowly, almost staring. I'm sweating even though it's cold out. My gaze lingers on things not here, my gaze mingles wonder at the nothing out there and the distance of what's inside me. And even though I haven't arrived yet I wonder what I'm doing here.

Here I am. I've been looking out there and I've been looking inside and it's the same thing. When I look out I see my lingering gaze, when I look in, I see my

gaze linger too. Am I the here of this place? And what's in me will soon be the here of where I'm going too?

It bothered me, the thought that I could project what's in here, me, out there. That I could spend my time leveling the place I'm in, insinuating myself everywhere.

But it's possible that it's the place I'm in, that it's not me. It's possible that what's out there is the same all over. Maybe it's so uniform out there that even the most discerning and motivated eye can't discern any difference, any distinction at all.

This is a comforting thought—that maybe I'm actually in a desert, that maybe I'm actually in a place that is the same all over. And maybe I'm a part of that place. The desert is a mirror too and its precise reflections reflect unaltered views to me, reflect unaltered views of me.

A Mirror Mirror

I'd like to start from the beginning. I'm going to tell you everything I know about the situation at this point:

I'm in a desert. I arrived only a few days ago. It's July, but it's a cold desert with plenty of ice and ash. No birds, no ground cover, nothing moving except the wind—just plain desert. Now I've always thought of the desert as a mirror because when you get out there and you're in the midst of it there's nothing coming back at you—just you. The desert is self-sufficient. Since there's nothing living in it, there are no demands made on anything from outside of it. So I've got this big mirror and everywhere I look, I'm in my face. Here or there makes no difference. I'm in the desert and I'm in my face wherever I go. Since the reflection's the same everywhere it has something of the character of a desert, so you might think of this as a kind of desert desert. And, all right, I'm not about to affect the desert since I can only get at myself wherever I go. That's one thing about the desert.

Now let's say I arrived in the desert in a state of boredom. Boredom is already a kind of desert because it's also a mirror. And it's also like a desert because it wants to make everything the same everywhere. So I've arrived in the desert and I've brought a desert with me. Now when you get into the midst of the desert it's impossible to tell where you are. Because if the desert is a mirror and it's reflecting me at myself, but me is a desert too, then I've got myself in a position where the mirror of one thing reflects the mirror of another thing but those two things are essentially the same thing, even though they're different. So you've got two

reflections that are the same thing but that come from different things that are essentially the same. So each reflection has arrived at this similitude even though they are different. Now the problem is I can't distinguish myself from the desert.

Once you get into a place like this it's easy to get lost. But getting lost in the desert of what you are is pretty much the same thing as getting lost in a desert, plain and simple. In a desert lost is lost. There are no landmarks here to show you a way.

So here you are, you're in a desert and you're bored and you're lost. Now it turns out that being lost is a kind of mirror too because nothing makes a difference no matter what you do. You're lost here and you're lost there and there's no difference between the two. So it turns out that when you get one mirror reflecting another mirror you get more mirrors. And once you get all these mirrors you get all these reflections. And mostly you just get reflections of reflections and it goes on and on so that you wind up (in Versailles?) getting endless generations away from the original reflection and then you wind up in yet another desert because it's pretty much impossible to distinguish between any one of these reflections. So here you have the nature of the desert more or less.

Hotel Búðir, Snæfellsnes (1993)

MONROE, ICELAND

I thought I'd take a picture. It was a sublime but common scene: the sun was setting, the waters of the ocean inlet were quiet, almost still. The light reflected in them illuminated the perfect symmetry, the perfect asymmetry of an undisturbed world. I lifted the camera to frame the shot, but the instant I found the image the view disappeared. In its place a mouth filled the viewfinder; a woman's mouth, voluptuous and soft. Her lips parted slightly as they crowded out the scene.

Instantly the view telescoped; uncanny and disparate things settled into profound intimacy. The landscape became sensuous white flesh and provocative moist lips. A few wispy blonde hairs here and there waited to be brushed aside.

It was a headshot. A portrait of Monroe. The one taken in 1962 by Bert Stern. The one that appeared on the cover of *Marilyn*, Norman Mailer's biography. It was this image that kept coming to me; coming to me like the scene of a crime or an accident.

After many years of travel, familiarity with the island had diminished the sensational element. The powerful stuff, the poetic and majestic stuff was all still there, but camouflaged now among the mundane and ordinary.

What could I do?—take the picture that would be only the most sensational thing, isolated and fixed; even though extraordinary things can't really be separated from the experience they offer. I could take the picture because the extraordinary and the ordinary are much closer than you'd think. I could take it because the sublime and the criminal are, too. But the view remained crowded, filled now with the inimitable symmetries and aberrations of an undisturbed and disturbing world.

(1993)

THROWING ITSELF TOGETHER

It's four in the morning. Excitement keeps me awake. Really it's kept me awake for years. The stinging briskness of the early morning cold puts the snap in everything around me. And the still light of the sub-arctic summer, with its pristine atmosphere, makes the seeable uniquely and deeply visible. I hit the road.

Half an hour out I come to an abrupt stop as the road drops into a river. I arrive at this glacier-engorged waterway and without hesitation, forge ahead on foot. Wading slowly into the middle, past the tops of my rubber boots and up my thighs, uncertain of how deep the water will go. Step by step the water soaks me, rising over my hips and up my waist. I move breathlessly as the water shocks and numbs. I look down into the opaque, white-green river. My chest forms a hole in it. My body disappears in the rushing water. The currents split around me, wrapping and hugging like a wet fur coat, oddly intimate. The acute cold levels feeling and difference: the numbing of my body extends it briefly into the realm of inanimate things.

Up the steep bank I slog, dead weight from the river. I lie down briefly, nuzzling my face into the plush and coarse but delicate ground cover. The wind blows without pause.

These mountains were fields before the crust split open and pushed the edges of a vast crack up high. The relentless blow of the wind shaped the ground cover into wavelets: a green and frozen ocean whose substance is still and whose look is motion.

But I haven't yet seen it, the lure that has compelled me for so many years and into this long night. It was described as a line of fire. The earth's crust started cracking up one night, slowly at first, a brilliant white light emerged: an instantaneous geometry. A long line, fresh, straight and narrow, and composed of glowing heat, as if glowing heat is the true matter of the sub-terrain.

It made sounds at first. Before the lava emerged from the earth it made whirring sounds, as of something spinning, of air rushing. And later, after the lava slowly began to cool, the sound of glass chimes could be heard in the fields as the recently molten rock contracted and cracked apart.

But now all I can hear is the wind. Keeping my eyes on the ground, protected from its fierceness, I wander, unsure of where to go but too determined to slow down. Checking the map would be a detour. It seemed to me that what I was looking for should be right where I was, more or less. I wander a little farther, believing I had already arrived at my destination but was simply unable to recognize it. After all, how was I supposed to recognize it? I'd seen photographs of parts, but here in the actual scale of a geologic event, the whole was too abstract. I had no sense of how the thing would come together, of what its actual would be.

Exhausted by the wind, I stumble forward as a break in the ground cover appears unexpectedly at my feet. I look down. A quarter mile over I see the edge, the other half of the crack. The thing starts to throw itself together right in front of me. I gaze into the v-shaped canyon below. It's vast, and even as I stand upon it, I am far from it.

Eldgjá. Here is Eldgjá, the chasm of fire, in all its elusive actuality. I've known this place better than experience could render. Eldgjá had reached the sublime a long time ago in years of imagining and anticipation. But this is the place a life of imaginings makes no less. This is the place that can't be imagined even as I stand upon it.

<div style="text-align: right">(1993)</div>

SOMETHING SHIMMERING

Outside the sky is vivid and bright: it's blue and the brilliant white clouds snap with pink. Their unusual shapes provoke no metaphor. Here cloud watching is not daydreaming. Cloud watching takes you to the heart of things, to a deeper, more elusive reality.

Each cloud settles into a nameless composure taking the shape of itself. That self is that particular cloud floating in that specific place and time. The clouds bundle together, cramming into one another, the occasional one floating lone and free.

Once, years ago, I lay restless and awake in my tent. Past midnight I stepped outside. A full moon, I thought, would confirm an astronomical influence. The planets attracted to my view were converging on my gaze: they gathered outside my tent.

How else to explain what I saw? To look at it, I discovered no object but a tremulous something. This something shimmered; that's all I could make out. There it was: a fitful shining, luminous and brief.

The planets gathered in my view, called together by my gaze; my gaze, called out by the view, called out by the planets as they composed the view, differently, in gathering. This is cause and effect.

(1993)

AN EVENING WITH GELATINOUS
AND GLUTINOUS

The sun sitting just below the horizon casts a warm glow over the village. The evening air was already cold and I was tucked away in my tent. A few days ago I had installed my portable cloth-home near the harbor where I worked. Beyond its thin, translucent walls I could feel the darkness gathering. The cawing of the ravens fighting or playing down on the beach inhabited the stillness that had settled. Their raucous noise infused the night.

After a dinner of tinned sardines and crackers I settled into my sleeping bag to read. Tonight it was "The Facts in the Case of M. Valdemar." In the story Edgar Allan Poe describes the transition of a being's spiritual cohesion into that of a detestable mass of malodorous putrescence:

> . . . the voice seemed to reach our ears . . . from a vast distance,
> or from some deep cavern within the earth . . . it impressed
> me (I fear, indeed, that it will be impossible to make myself
> comprehended) as gelatinous or glutinous matters impress the
> sense of touch.*

In the dimness of the candle-lit tent, I imagined a gelatinous or glutinous substance. Something not unlike aspic. I imagined a heavy, sedentary material that bulged under its own weight resulting in the look of a perpetually bloated thing. A quivering transparent mass soft to the touch, deforming when pressed, with bright reflections wrapping about the subtlest distortions of its surface.

A humid atmosphere, one in which mold flourishes emanated from this thing. So now a viscous slime was before me. The throbbing mass of colorless goo in *The Blob* made a similar impression. Lying in a field just outside of town,

Steve McQueen discovers a possible extraterrestrial gelatin.

I imagine the ectoplasmic substance conjured by Poe's story. I imagine it worked up to a table-sized portion, something in the scale of meat loaf . . .

(1994)

* Edgar Allan Poe, *Poetry and Tales*, "The Facts in the Case of M. Valdemar," The Library of America,1984, New York, p. 839.

CLOTH-HOME CULTURE

I never found out where I was going. When darkness fell, the rain came too. I kept moving though, looking for a sheltered place in the landscape. But there was nothing. A vast flat plain: no landmark, not even a hill or an outcropping, no vegetation, no variation; just the unpausing horizon: black below and darkening quickly above.

The rain grew heavier. The light beam of the motorcycle ignited each drop in the darkness ahead. But the sparks of light receded at the same rate as my approach, a changing view that remained static. Watching it was mesmerizing and exhausting. In the accumulating cold and wetness, I wondered what measure would bring arrival? Would it be discomfort, depletion, shock, despair? For now it seemed elusive.

But I was getting close; the pauses were adding up. I felt it. I sensed my expectations waning; their slow dissolution allowing or revealing the destination.

The dirt road is built up over the black sea-level plain. I cut the wheel westward toward an unseen ocean, heading off into the vast roadless expanse. Glimmers of moon shine roll far off in the distance. The break in cloud cover was all I needed.

The winds were getting nasty, whipping at me, blowing the bike down. I pull the tent from my pack, the ripstop billows briefly, matting down quickly with water. I stake it, throw my stuff in and slip inside. The space between my face and the tent is still and dry. This small quiet is contained within the frantic-sounding noise of the smacking cloth.

I undress and slide into the cold nylon sleeping bag. Into the stillness, I feel my energy dissipating. Gazing at the ceiling, I'm too weary to close my eyes.

An occasional blink brings relief, briefly extinguishing the loudness of the tent. Each blink prods and damps me.

I lay in a puddle slowly gathering depth. I lay in this cloth-home, a pause waiting to end.

(1995)

THE OTHER HERE

Up on the second floor of an old house very near the Arctic Circle and overlooking the ocean in a treeless landscape is a room filled with airy vacancy. Now, as I stand here a diffuse white light surrounds me—white light framed in a milky, dry blue the exact hue and tint of which were cooked up in decades of Arctic exposure. A sky of nameless color admits a blank light and, from here to there, even for great distances, no variation. It grazes the water out in the farther reaches of this rarely visited view. As this light, the view enters the room.

Here in this empty room a rough, plain wood table is set more or less in the middle of the space. In the corners and along the juncture of the floor and walls single bits and tiny tufts of airy down gather together—an amplified dust. On the table a collection of down forms a geometry of unknowable dimension; but in its soft definition a comforting measure resides.

Occasional clumps cling to the table legs and catch high up on the walls in odd, unreasonable places. This plumage is more loft than thing. In its almost weightless state the feathers tremble perpetually; perpetually since each clinging imperceptibly barbed clump quivers in the presence of itself. It is a movement that cannot be seen among things too light to be still.

(1997)

WATER AND CLEARING
(Excerpt)

Hot water outdoors, especially in a cold climate, provides occasion for a unique experience of shelter. If the climate isn't cold it won't be shelter. Stepping out of the chill, entering the hot waters of pool or pot is a special opportunity for the experience of inside; to have it, you must go outside.

How far is this idea of shelter from architecture? Being inside is not an architectural concept; being outside isn't either. But recognition of space distinct from space-at-large is one beginning to architectural order.

Sitting outdoors in hot water on a cool day you enter another space; thus begins an act of clearing. Clearings have no inherent properties except difference from what surrounds them. Hot water outside expands space, increasing the distance to what is near. Which is not to say that when you sit in hot water under the open sky everything near is faraway. But rather that you sit among the near in a different way; by being in another and distinct space planted in unique relation to the world at hand. Also, you sit among the far, the big, and the beyond in an intimate way. That space is built from difference, especially difference in temperature, but also comfort: both psychological and physical, and then the form homogeneous things take when you enter them or they surround you.

Water tends to find or create the space it exists in. In the simplest hot water structures of Iceland, local rubble is used to divert and mix hot with cold water. The resulting warm water then finds a natural or enhanced clearing in which to gather.

In some remote places, not justified by demographics, pools are constructed. Empty concrete basins are built into the earth and filled with water mixed down to a delicate experience of warmth.

The perception of warmth is intimately dependent on ambient temperature. And thus, a profound exchange with place is established: being in the very spot one

is in and nowhere else; your body temperature, that of the water and that of the air are all linked precisely in you, in the sensual perception of difference.

One of the strongest aspects of clearing in these remote locations is the extreme rural aspect. You are in a place in a faraway location that is without other activity or occupation.

Clearing is an act of recognition; the experience itself, one of shelter. Limiting the idea of shelter to weather has produced one kind of structure. This is another.

<div align="right">(1998)</div>

CONJECTURE A CAUSE:
SELJAVEGUR 2, REYKJAVÍK 101,
AUGUST 22, 2003

1

I want to watch, to watch out the windows. It's nerve-racking to sit and look from one position. There are so many views in all directions and I never know where the next event will come from. I watch. Yet so much of what I see is unexpected. I see things unseen before, that is, things I've never seen before; and in their singularity and exact circumstance no one else has either. For instance— now in the small hours of the night a black cat strolls across the street below, a dark knot of something swinging from its jaw. At the same time—on a still sea in the farther reaches of the view a luminous, daylight-like-blue inhabits the water. It's brighter than the sky. I watch it, a mystery unfolding. Even with a conjecture of cause the mystery remains. I keep looking, thinking maybe I've seen it before, waiting for the moment I will know, or for the next mystery to obscure the view. But before this mystery ends it disappears from sight. At some point it simply isn't there. And now that it's gone its absence changes everything. With no beginning—like a river, stepping into it—somewhere along its way, stepping into the endlessgoingonneverbeginningneverendingness of it. An act with no moment in time to distinguish it.

The continuous flow of mystery out there (in plain sight) makes every interruption a source of anxiety. When the mystery is so densely packed and elusive I know just a brief distraction will mean missing the thing I'm involuntarily calibrated to anticipate. And when I turn back to the view, it's more vivid, more intense, but I'm even more certain that I missed it. It happened just the moment before when I was distracted—by the sour taste in my mouth, the noise on the street, etc. But what happened, what did I miss? Can't say; but now the view is

laden with anxiety, tinged with the missed thing. Like getting lost but still being in the place you need to be; until the next missed thing comes along and the previous one is locked into history; and so, I enter a cycle of missed things.

It's pointless describing what's going on out there. But the urge to see the view, to secure the memory of it is compelling. To be held by it that I will be able to hold it in me—make it a part of me, like a cell somewhere deep in my body. Fixed for beyond now, take it to the next place, wherever I go—to Sicily or the kitchen.

But still: watching it, watching and feeling how inconclusive it is just to experience it. And the inconclusiveness eggs me on to watch further—but it doesn't get clearer or more complete—it just gets more nebulous and elusive. It just grows more: *more* packing *more* into more—it keeps piling itself into me without end. So here I am soaking up the view and aware that as it continues to gather in me—to call me out and claim me, that even when I leave here—the longing created by it—will haunt me. Haunted by the yet unseen. These views are inescapable now.

I try to imagine the view without me, imperceptibly changed by my presence—what could it be without me? My imagination is never quite specific enough. I can't quite get it except in the warp of consciousness that only reflects the view as it is when I am present. I am captive to this unseen essence. Its mystery floating out there beyond my grasp, the other half of here.

Some evenings the whole thing turns into a spectacle. Like an accident or a violent event and I can't stop looking. These spectacles occur on a fairly regular basis, a serial act of violence shaking things up and altering them for the time being which is also likely forever. These casual and common moments of the thrilling and unique come disguised as prosaic light and air.

2

You consume with your eyes. And eyes are voracious. The stomach has a size. It will only fit so much. But the eyes? The eyes are the essence of acts—energy and connection. To see: here where the sea surrounds me. To sea: water is an act too. Just a brief time in this room and you can't stop watching. You think eventually you will get enough. But satisfaction and familiarity don't come. You just keep wanting and waiting. Wanting and waiting, needing more. A meal that does not end.

How long can you keep your eyes shut when you're not tired? Not long, fear or longing creep in, or just an itch. You open them to check, just to see. See what? Check on what? Consciousness? On what's going on? Or just to assure yourself of going on? So what if it's imperceptible.

3

I want to watch, and this desire doesn't abate. Watching is a form of waiting. Waiting, an act defined by its indeterminate extension in time. To watch. To wait. To water.

Enter the garden.

But *garden* is an act too; essential act of becoming: to garden. A garden is always on the way to becoming itself.

So here in the garden of my sight. What do I see?

Can't really say. Can't name the site, can't name the sighting—even though an ocean of sites, of sightings. Nothing tangible, no geography, no morphology. Just out there . . . is that light?

So here in the garden of my sight. What do I see?

Can't really say. Can't name the site, can't name the sighting. Nothing tangible, no geography, no morphology. Just out there . . . is that light?

Don't know. Just something; a garden beyond delight.

How far?

Don't know . . .

(2003)

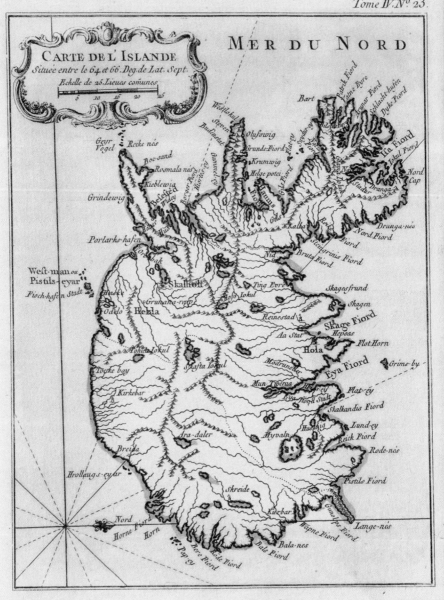

MER DU NORD

CARTE DE L'ISLANDE
Située entre le 64 et 66°. Deg. de Lat. Sept.
Echelle de 25 Lieues comunes
5 10 15 20 25

Bart

Geyr
Vogel Reike nés
Boe-sand
Rosmala nés
Kieblewig
Grindewig Belefted
Porlarks-hafen

West-man ou
Pistils-eyar
Fisch-hafen Stadt
Oddo Hekla
Skalholt
Grunana-rup
Lohida Iokul
Tocke bay
Kirkebar
Ara-daler
Breida
Hrollaugs-eyar
Nord
Horne Fiord Horn Skreide

Olufswig
Grunde-Fiord
Krumwig
Helge potei

Westlokul
Steven
Budsdatal
Gammel-ey

Hurdis-ey

Hun Fiord

Gols

Nid

Kalba

Patrick Fiord
Patne Byre

Arnar Fiord
Schlacht-hufen
Dyke-Fiord

Ifa Fiord

Iokul Fiord
Nord
Cap
Dranga

Dranga-nés
Nord Fiord
Fiord
Steingrinis Fiord
Brute Fiord
Skagesfrund
Skagen
Skage Fiord
Hepsas
Flat Horn
Grims-by

Bofs Iokul
Ting Evre
Reinestad A.
Aa Stat
Modruneue
Mun Tiverna
Skalkandis Fiord
Lund-ey
Reick Fiord
Rode-nés
Pistils Fiord

Ting Evre
Hola
Eya Fiord
Flat-ey
Skafta Iokul

Myvaln
Kirbar
Gimerfes Fiord Lange-nés
Wapne Fiord
Bala-nes
Bals Fiord
Reile Fiord
Pap-ey

NOTES ON THE OBSOLESCENCE OF ISLANDS

Islandhood is over.
(When did it become an event?)
- Islands as whole places, complete places.
- Islands as separate from-everywhere-else. As isolated places.
- Islands as solitary places.
- Islands as faraway places.
- Islands as refuge.
- Islands as places unaffected by other places.
- Islands as original places, unaltered places.
- Islands as unwitnessed places.
- Islands as unknown places.
- Islands as inaccessible places.
- Islands as places of nowhere.
- Islands as figments of the imagination.

Islands exist only in the nominal sense now.
- Islands are still facts.
- Islands are still on the map.
- Islands are still in the oceans.
- Islands still form. Surtsey (off the southern coast of Iceland), for instance, started emerging from the Atlantic Ocean in 1963.
- Islands still form. Psychological islands, for instance; questioning, testing "no man is an island." A "lone wolf" answers. Unabomber—Ted Kaczynski, for example. (Public notice began with a package posted to Buckley Crist at the University of Illinois in 1978; it was Kaczynski's first mail bomb.)

Islands have lost their definition, their identity.

The gradual and ceaseless corruption of distinguishing forces and properties has brought about the disappearance of islands. This disappearance is universal. Not only is islandhood over on earth but also in the Milky Way, formerly referred to as an "Island Universe." And soon the galaxies or island universes beyond.*

Distance is no longer a measure of separation.

When all is accessible, nothing is faraway. With the recently published images of black holes in 2019 does faraway even exist?

Islands no longer end.

- Non-island things bleed into islands everywhere.
- Islands still have edges, but they no longer have ends.

Islands are now contiguous with everywhere.

Silent Spring's[†] kind of everywhere.

- The everywhere of pharmaceuticals and fourth-class drugs. Zoloft and cocaine, for example, have been identified in the coastal waters of the most remote areas of the globe.
- The everywhere of industrially distributed hormones and antibiotics. Especially insidious is delivery through meat and dairy consumption. One documented side effect: wild male salmon of the North American northwest no longer have male genitalia. Does this make them females or eunuchs?
- The everywhere of pesticides, insecticides, herbicides, and mundane toxic chemistry. DDT, Roundup, Agent Orange, PCBs, *Fantastik*, Windex, and Teflon, et al. One documented side effect of DDT, for example, is hermaphroditism. Hermaphroditic polar bears have been observed in arctic regions. While some think this will double their chances, it also makes them sterile.
- The everywhere of raw and treated sewage in an overpopulated world.
- The everywhere of industrial waste. Both by passive distribution and shipment all over the world.
- The everywhere of leaked petroleum, so-called black gold.
- The no-escape everywhere, the pernicious no-escape everywhere of radioactive materials.
- The everywhere of disease and bacteria as they are distributed by tourists throughout the world.
- Plastic, plastic, plastic. Much of it now micro-plastic. Disposed-of plastic,

"disposable" plastic was never more than a misrepresentation. And now, evidently, only an oxymoron. Disposable plastic is not disposable because it *never goes away*. One side effect of micro-plastic: "voluntary starvation." Seabirds and filter feeders mistake a stomach full of micro-plastic for food.

- The weather is rarely local now. Your weather is my weather, regardless of relation or proximity. Weather is always personal now.
- Mass communication technology erases or destroys boundaries, satellites and the internet, for example.
- The everywhere of software facilitated economies. Algorithms have insidious influence; especially on value.
- The everywhere of software facilitated cultures. Algorithms have insidious influence; especially on identity.
- The everywhere of zombie jellyfish; jellyfish colonize other versions of themselves, overpopulating the oceans through mutant immortality.

The loss.
- The loss of islandhood.
- The lost possibility of being lost.
- The lost possibility of getting lost.
- The ever-growing transparency of political, social, cultural, and economic exchange. This is also the loss of privacy.
- The violation of one's relationship to one's self through the non-stop tracking and surveillance of our behavior by technology corporations, with and without permission.
- The loss of privacy is the loss of solitude.
- The loss of solitude is the loss of imagination.
- The lost potential of imagination.
- The loss of a personal relationship to the future.
- The lost possibilities . . .
- The loss of possibility?

(2003/19)

* *Kosmos*, Alexander von Humboldt, 1845–62.
† Rachel Carson, *Silent Spring*, 1962.

ERUPTION, ASSASSINATION
(NOVEMBER 1963)

On the 15th of November 1963, not far off the southern coast of Iceland, the volcanic island of Surtsey began its explosive emergence from the sea. Seven days later President Kennedy was assassinated in Dallas. When I was a child I watched these near-simultaneous historic events unfold in non-stop televised coverage. Surtsey billowing pillars of salty steam for days before the island landmass became visible. And JFK in the backseat of his open limousine unexpectedly slumping over, hit in the head by sniper's bullets. Only the aftermath of the event was visible at the time. The act itself was hidden in its own brevity.

As the coverage expanded from hours to days, this unlikely public pairing fused into a formative event in my life. The eruption, the violent snuffing out, the fiery emergence, the spectacle, the explosion of brain and molten matter, the tedious and excruciating close-ups, the smashing apart, the view hidden by smoke or speed, the revolting details, the hyped-up drama of something truly dramatic, the news on a seemingly endless loop, with each repetition a magnification of the impact, the photographic evidence, and the peculiar aggression of stopped action, the brute irrevocability.

(2013)

A WHITE STONE

In May 1979, I was exploring Bakkafjördur on the northeast coast of Iceland. The sky was sitting on the ground, the fog of it obscuring the view. Across the narrow valley I could just make out a group of Quonset huts. Not memorable really except for the fact that they were made of concrete. An extravagant bit of engineering I thought at the time, and funny too.

Aimlessly I wandered along the bank of a still stream; I wasn't going anywhere. Among the dark rocks and black earth of the riverbed I discovered a white stone.

I have it in my hand now.

The white is translucent and sort of dirty, and you can see that something is trapped inside; a denser space in there—like a shadow or a mystery darkness. Sure, I will never know what's in there, but I like knowing that something is.

A capsule of white stone, probably quartz. Rolling it in the palm of my hand, considering the size and weight; the surface is baroque with detail but also smooth and edgeless. It offers me softness after all these years. The stone is whole, complete, not a fragment of something else. Molded inside the space of another thing, it is a memory, a physical record of a now non-existent place.

For almost forty years I have enjoyed this stone, its scale so perfectly compatible with my own. In the fractional non-geologic infancy that is my lifetime, I have accumulated. Enough of me, to become a mildly erosive force as I feel the softness and smoothness of this white rock intensifying over years of intimacy.

(2018)

MY OZ

(2006)

MY OZ

Keynote Speech, Class of 2006
Iceland Academy of the Arts, Reykjavík

1

I know you were expecting Dolly Parton, but I'll be standing in for her now . . . just close your eyes and I'll tell you a story. . . .

Let me approach this talk by suggesting ways for us to imagine a future. Talk about the dire need in our time to be critical, to question, and above all not to be passive. Things that I believe are essential to us anyway—more so now than ever. We have witnessed the obsolescence or is it extinction?—of islands in our time. Iceland is no longer an island: economically, chemically, climatically, and even psychologically speaking. This is a consequence of Iceland's expanding relationship with the world at large, both voluntarily in the form of economic interests and communication and involuntarily in the form of pollution and inappropriate political pressure. It is also the consequence of an overpopulated, increasingly polluted planet. And this fact necessitates a new approach to maintaining the integrity of Iceland's land, water, and culture.

Al Gore is down at the Cannes film festival talking about global warming. And it looks like the Americans are cooking up the next big wave in entertainment—global climate catastrophe. I know it's been in development for some time. It seems the only way for us to acknowledge climate change is to make it part of a capitalist venture. In the last ten years the value of art has gone up astronomically. As the economic value of culture increases it can albeit inadvertently become a more effective tool through which to realize political and moral responsibility. This is especially true in mass media forms like film, music, and literature.

However, an unfortunate side effect at least in the fine arts is the degradation of meaning in art. This is the consequence of the very recent phenomenon of

extreme commodification. Today as some of you may already know people buy and sell art in ways not unlike stocks and financial instruments, based exclusively in investment potential.

Speaking of the fine arts in particular the vast majority of what is being produced today only exists because it *can* be sold. Very little of what is created is motivated out of the necessity of the individual. When artists play to their audience it always results in compromised work. And artists above all must exercise critical judgment with regard to the demand for their work.

But I promised myself that I would try to keep it light, to honor this occasion that addresses the complex future facing all of us. If my mother were still alive, she would urge humor and if I could just mix that with a little weather or even water I think we'll be off to a good start.

So I thought I'd begin by suggesting a new word for the Icelandic language:

relaxness*

A conflation of English and Icelandic, it means—reading Halldór Laxness feels good.

2

I thought I'd start with the weather—since this is or certainly was one reason to become a permanent tourist here. My status as permanent tourist, something I invented over the years of coming to Iceland, allows me the distance I need to be near it. For me, it seems my nearness to Iceland is something I can only have by keeping this distance. There was a point early on in my visits that I was so taken with this landscape I wanted to experience everything: every road, river, mountain, and rock. When I was twenty-two I fantasized about retiring and doing a complete inventory of all the rocks. But short of that, I just went out. It started with a tent, walking and hitching. Then after I graduated from university I was given a travel grant. I bought a motorcycle and shipped it to Iceland. And for someone who had no money it was a great way to get around. It was the coldest wettest summer on record at that point. So, amidst all the sublime moments there was a certain misery to it all that I thoroughly enjoyed.

I developed an exquisite sensitivity to the landscape and the weather. Indoors I became anxious when I turned my back on a window for fear I might miss something. Especially on a clear cold night when there was a chance the aurora might perform. When I was a kid my first experience of the northern lights became a touchstone. It happened in a suburb north of New York City. From my parents' driveway I saw the lights, and it seemed to be something opposite to all I had known. Ephemeral, intangible, beyond simple understanding. It was a kind of epiphany—a moment of enlightenment for a young person living in a highly material world with all the illusions of permanence. I understood in the presence of that fugitive display the potential that existed out there that would always and thankfully be beyond my grasp. But the northern lights from a suburb of New York City is one thing, from a mostly uninhabited landscape, another.

3

Now the weather is an important thing in our lives. It's no longer simply an occasion for small talk. It is constant in its indifference to us and unpredictable in every other way. It keeps circumstance complex and beyond our final control. I think it is essential to have something that tells us who we are. And weather has a way of doing this.

I have always taken the weather personally. Was it Freud who said "talking about the weather is talking about oneself"? And I am as attracted to weather as much for what it is as for what people have to say about it. The beauty of weather and what now becomes a great challenge is that we all share it equally. At this point in history it may be the only thing each of us holds in common.

One of the projects I have in development here is a collective self-portrait of Iceland—I'm more or less ghost writing/producing it. I'm collecting through interviews the stories each of us has about their weather. My own starts something like this:

> My weather began back in grade school. In class the teacher
> announced a hurricane was on its way. With that she dismissed us
> and emphatically instructed: "Run home!" I guess it gave me such
> a thrill I've been running to Iceland ever since.
> —from *Weather Reports You*

But here in Iceland dramatic weather is not necessarily the most memorable. My time here has brought me an awareness of the less perceptible things. And being

here has exerted a great influence on my work. It was in the matter of learning to see, in the sense of experience, that Iceland became essential to me. Sounds like a simple achievement, but it's an act of will that took me years to grasp. I learned to be present in the here and now, I learned the unchangeable nature of each moment as it passes and locks into other moments forever. I learned the importance of being in the place I am, of paying attention. That was my discovery of the Highlands.

<div align="center">4</div>

In 1990 I wrote about my time in the Highlands:

> You use the desert as measure, as lucid reflection. It gives nothing. What you take from the desert is who you are more precisely.
> —from "Anatomy and Geography," 1991

Also about that time—

> Big enough to get lost on. Small enough to find myself. That's how to use this island. I come here to place myself in the world. Iceland is a verb and its action is to center.
> —from "Island and Labyrinth," 1991

And it's no coincidence, as Jules Verne discovered already in the nineteenth century, that the entrance to the center of the earth is actually located in Iceland. He may have been inventing a fiction at the time. But I have, in my travels here, discovered its reality.

Well now that the weather has improved, so to speak, here in Iceland I often have the sense I could be in Florida. One thing I loved about the so-called bad weather was that the rainy, misty days would only reveal a small portion of the view at a time. I spent many, many days in fogs that allowed only enough visibility to inspire mystery. So, I kept coming back to get the rest of it. And that was years of coming back to see the same thing that was also completely different.

But of course, there are yet passages of Iceland I have not traveled to. And even now I feel the magnetic pull of these places. I imagine I will never go to them—just to keep this energy alive in me.

5

The Wizard of Oz brought me Kansas, if only briefly, when I was young. And to this day Kansas is still one of the places I've never been. But since I watched Judy Garland journey to Oz, Kansas has inhabited my imagination, and Toto too. In this way we come to dwell in places we've never been. It's a form of dreaming—these unseen places, only known through rumor, word of mouth, flight of fancy, a map—or no map, just a story told. We need the idea of them, the idea that from early childhood has become a part of our identity.

The existence of these unseen but accessible places is of profound consequence. They dominate the geography of our imagination and dreams. To recognize that some of them are real is essential to the life of our dreams. They offer us extension and breadth, hope and faith. We need these places that we've never traveled to, that we may never go to. We need them not for escape, but for measure: of all the places we have been to, and of ourselves as well. We need them as a way of balancing what is with what might be, and as a way of understanding the scope of things—of admitting that the things beyond us are also the things that define us. These are places that are at once both actual and acts of imagination. They function to keep the world large, hopeful, and unknown.

These rarely experienced places are no less valuable than those we occupy daily, no less inhabited by us than our most familiar and intimate ones. In acknowledging them we understand that we are something more than the body we inhabit and the things we consume, and that we dwell in places beyond our immediate perception or reach—so that we may see beyond our sight.

It is common to believe that because we will never travel to them, their loss will have no effect on us. Or that losing a place that is not occupied by humanity is a loss of no importance; that going from unseen to nonexistent will make no difference. But the difference runs deep. We are losing the core infrastructure of our imagination.

—from *Iceland's Difference*, no. 23

I wrote this text[†] prior to the building of Kárahnjúkar dam. But now I see that it applies to many things: the future of ice and the future of whiteness, and in a sense the future of north as well.

6

> When I went to the North, I had no intention of writing about
> it. And yet, almost despite myself, I began to draw all sorts of
> metaphorical allusions based on what was really a very limited
> knowledge of the country and a very casual exposure to it. I found
> myself writing . . . critiques, in which, for instance, the north—
> the idea of the north—began to serve as a foil for other ideas
> and values that seemed to me depressingly urban-oriented and
> spiritually limited. . . .

This is from Glenn Gould as written for his self-produced radio program *The Idea of North* (1967).

I go north. It's in my nature. But it turns out that the vast majority of people go south. To the sun and the heat and perhaps the more social nature of life in southern climes. The desire to go north is an attraction to solitude, open space, subtle expressions of light and time. Vast expressions of scale and horizon. Sometimes going north is about whiteness. Sometimes it's about darkness. I'm attracted to the darkness, it relieves me of the incessant call to visual attention. It opens interior spaces that offer untold possibilities of discovery. This darkness is really another form of light. It nurtures the wilderness inside me. That wilderness and what it takes to sustain it may be different for each of us. The fact of this wilderness, the necessity of it, is basic to individual well-being. And each of us must find a way to keep this space whole in themselves. As an artist so much of what one does is based in faith—in a belief that exceeds or ignores society's interest. Pursuing creative instincts demands faith, endurance, and intelligence. It demands independence and simple strength as well.

7

I have spent many key moments of my life here in Iceland. I have used this place as an open-air studio of unlimited scale and newness. In retrospect I see that I have chosen Iceland the way another artist might choose marble as the substance of one's work. Iceland taught me to taste experience. Because that's possible here, possible because of the intensely physical nature of experience on this island. This palpable quality has been one lesson. Sensual experience balances the intellect and here the best of both worlds exist in provocative union. This added dimension that presence

gives to experience is partly how the landscape here mastered me. Presence is the thing sensed, never known. And this has become an essential ingredient in my work.

Part of my desire is to equate the meaning of my work with the experience it offers. This Iceland taught me too.

8

In 1982 I stayed in a lighthouse for two months. I had been living in urban areas all my life, New York, Providence, New Haven, and I had this idea that I'd go to the lighthouse in southern Iceland—I had known of it since my first trip—and I'd just "let the sea lie before me." That was my ambition, to see if I could—just let the sea lie before me. I was haunted by the desire—of seeing a landscape as it is when I am not there. I know this sounds absurd, and the effort was full of absurdity, but for me it was a completely new experience, a true adventure. An Arctic explorer, I've forgotten who, said that having an adventure is a sign of incompetence. I would find out one way or another. The adventure of just being here. Not wanting to change here. This remains an elusive desire. In some sense too simple to achieve. I come to Iceland to discover this possibility still.

9

This talk is equal parts love, faith, and fear. Love for the uniqueness of your island, your culture, and you. Faith, that you will invent a future that does not forsake the essence and uniqueness of this island. But then being a realist I also have fear. Fear for a future in which Iceland fails to take responsibility for its uniqueness.

I wish you luck. But as Emily Dickinson said:
Luck—is not chance.[‡]

(2006)

* See Icelandic Nobel laureate in literature (1955) Halldór Laxness.

† Unpublished text written for *Morgunblaðið* newspaper, Reykjavík, 2003.

‡ Emily Dickinson, "Luck Is Not Chance (1350)," ca. 1875, in *The Poems of Emily Dickinson*, vol. III, ed. Thomas H. Johnson (Cambridge, MA: Belknap Press of the Harvard University Press, 1955), p. 932.

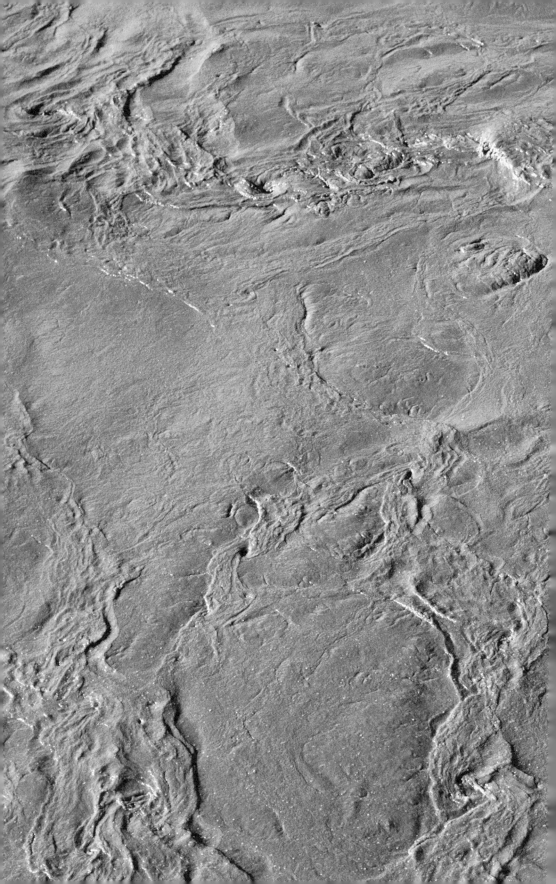

WEATHER REPORTS YOU
(EXCERPT)

(2007)

INTRODUCTION

A Collective Self-Portrait

My weather began back in grade school. In class the teacher announced a hurricane was on its way. With that she dismissed us and emphatically instructed: "Run home!" Scared at first, exhilarated afterwards, I ran all the way. At home I crouched beneath the picture window watching as the sky turned green and the trees whipped and snapped in the wind.

Everyone has a story about the weather. This may be one of the only things each of us holds in common. And although it varies greatly from here to there—it is finally, one weather that we share. Small talk everywhere occasions the popular distribution of the weather. Some say talking about the weather is talking about oneself. This seems to hold true in a general sense on an individual level. But for entire populations as well the weather is reflection and measure. In this century, as young as it is, we have merged into a single, global us; with each passing day we can watch as the weather actually becomes us. *Weather Reports You* is one beginning of a collective self-portrait.

Ghost-Producing a Self-Portrait

We took oral reports on location that were then transcribed, edited, and translated. Word of mouth directed us from one participant to the next. For this initial production we limited ourselves to the community of Stykkishólmur and the immediate outlying area with one exception. Oddný Ólafsdóttir was a test-report that we used to help develop our technique but was retained as a hint of what is to come. Gathering reports

from other parts of Iceland will mean a portrait of greater nuance and complexity. The prospect of worldwide collection offers the possibility of the collective self-portrait as a debabelized language. As the collection grows, so too, the resolution of this portrait. I imagine an eventual resolution so rich it becomes the subject.

A Collective Self-Portrait Is Closer to Paradox Than Oxymoron

Although there are many similarities, each community, as well as individual nourishes its own particular awareness of weather guided largely by basic geography. I imagine the weather reports of Laramie, Palermo, Hudson Bay, Gorky, Lake Baikal, Timbuktu and so on. Iceland is only a starting point. But Iceland more than most places is a country that has forcibly been made to recognize the weather as the dominant, essentially unpredictable presence that influences the outcome of all things on the island. The history of Iceland is in great measure a history dominated by events of weather and geology.

It is 2006. Weather is the essential paradox of our time. Weather that is nice is often weather that is wrong. The nice is occurring in the immediate and individual and the wrong is occurring system-wide. The scale of event abstracts it from easy recognition as the natural inclination to accept, masks nasty as nice. It is a winter night here in New York City, mild and still. I spend the evening over dinner outside, as the weather reorganizes geography and relation around me.

A Serendipitous Coincidence

In 1845 the first regular measurement of the weather and meteorological record keeping in Iceland began in Stykkishólmur with Árni Thorlacius' efforts. The opening chapter of *Weather Reports You* is also in Stykkishólmur. In the early '90s I was passing through the town and noticed a building that overlooked the ocean. It wasn't just the look of the building with its gas-station-Deco styling, or the fact that it reminded me of a lighthouse. What really caught my eye was the location at the highpoint of town. That it was built as a library only added to its appeal. From that connection has come *VATNASAFN / LIBRARY OF WATER*, the umbrella work that includes *Weather Reports You*. What initially appeared a delightful coincidence, now seems a kind of destiny.

Weather Reports You is produced as part of *VATNASAFN / LIBRARY OF WATER*, Stykkishólmur, Iceland.

SELECTION: 21 REPORTS

Jóhann Pétursson
Born 1918, Stykkishólmur (Died 2006)
Retired lighthouse keeper at Hornbjarg

One winter when I was little there was so much snow that my father had to go out through the upper floor window to dig his way down to the door. Imagine that snowfall! That's unknown these days.

When I was at the Hornbjarg* lighthouse everything revolved around the weather. I could almost say that I shifted my position in my chair according to the weather. I could feel it all. The weather and weather measurements. I had to record the weather at three-hour intervals round the clock for twenty-five years.

I had to go up onto the mountain every single day, whatever the weather. So I ought to have some definition of the changeability of the weather. But I'm such a blockhead. It's a fact that even if you do something daily that has an effect on you, it's as if it never sticks in your mind as a special phenomenon. Unless you're hit over the head! But sometimes I feel my whole life was spent more or less in peril.

* Remote area in the northernmost part of the West Fjords, only accessible by sea.

Erla Harðardóttir
Born 1954, Hvammstangi
Housewife

When Hekla erupted, I was just a little girl then, I think it was in 1970, and I was at home alone with my sister. My mother was at home most of the time but had popped out to visit someone, we were alone there and in the middle of the day it suddenly started to get dark, like a veil covering the sky. That was the ash from Hekla. We didn't know what was happening when it suddenly got dark in the middle of the day. Then we heard on the news that there was an eruption. When we went to school the next day everything was grey, I think it was the last day of term, in May anyway.

Apart from the fact that my father drowned in a storm the weather hasn't had much effect on me. He had a pleasure boat and still went to sea. It was in September 1970. He went all the way out into Húnaflói Bay, the weather was bad and he was found on an island off Hólmavík. After having my children I've become more frightened, more scared of flying in bad weather. But I often feel good too, like in the old days when there was maybe a blizzard day after day and we got out of having to go to school, maybe there was a power cut and we had grapes from barrels like they had in the shops before Christmas in those days, and we sat in the candlelight, peeled mandarins or oranges and squirted them at the flame. That used to make sparks.

When I was little, we sometimes had to crawl out through the doors to be able to clear the snow from them, the snow made everything dark, piled right up over the windows. We had to dig tunnels. And when we lived in Patreksfjörður, I remember my daughter, my second child, climbed up onto the roof of the house we lived in then and jumped down into a snowdrift.

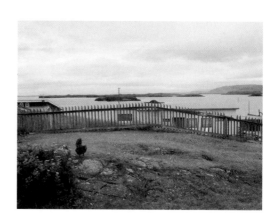

Anna Sigríður Gunnarsdóttir
Born 1960, Reykjavík
Nurse at St. Francis Hospital

Several years ago I was very depressive, I often used to think then that you don't know which came first, the chicken or the egg, if and how the weather affected my depression, for better or for worse. And I remember at that time I was shut in here by myself a lot, I shut myself away and there was an incredible amount of salty northerly storms. No snow on the streets but brine and seawater spraying everything so all the windows turn grey and the asphalt jet black although it is just dry. If you pull yourself together and go outdoors to scrape the salt off it gets a little brighter, you feel a little brighter. If there'd been warm sunny weather I wouldn't have needed to go out and scrape the windows clean! But I doubt I would have been so depressed in warm sunny weather. But there's also the question if I felt the weather worse because I was unbalanced.

I go through mood swings and if I'm full of self-confidence then the stormy winds are just brilliant, and the rain and the gloom and everything that would stick in my head if I was feeling down.

If I'm in my stride I feel good in a snowstorm. For example, the best thing I know is going swimming in drifting snow and blizzards. Swimming like mad and then getting into the hot pot at the swimming pool. Feeling

those extremes, the heat and the cold. Then maybe one day I wake up and there's that sort of weather and it's repellent. It's difficult to work out this interplay of mood and weather.

I adore the weather that they call a light breeze on the weather reports, it refers to the rippling sea and is next door to calm. It's brilliant to go rowing then. Calm weather. That's precisely the description of a good state of mind, that calmness. And fog, even. But calm. Wild weather's a challenge too if you're in that frame of mind.

Elva Rún Óðinsdóttir
Born 1989, Stykkishólmur
Fish factory worker

I can't recall any serious weather here. No, I don't think there's anything. I don't think so. But Jesus, when I got confirmed, the weather was crazy then and I had to put a bag over my head to keep my hairdo in place, and of course it blew away. There was so much wind that I had to fight my way to church. That, for instance.

Ólafur Arnar Ólafsson
Born 1940, Ísafjörður
Retired policeman

I got to know Icelandic weather as a fisherman from an early age. Actually I have a nickname. I was a skipper in Ólafsvík and one day they were all going to stay in harbour except me, so I set off and then they all came after me. But then they turned back but I went on, and so I earned my nickname: Storm, Óli Storm. And I've always felt good out at sea even if it's stormy. I feel good in storms.

I never feel bad. Perhaps it was better when I was fishing if the weather was reasonable, but I didn't necessarily feel bad even in rough seas for days on end. I remember when I was a skipper on a ship from Ólafsvík and we were sailing to Britain, and when we were leaving the Pentland Firth to the south, the foulest weather struck that I've ever seen. I think seven ships sank in it.

I remember one incident. It was fine down here but a raging storm up in the hills and a coach full of French tourists overturned onto its side at Stórholt and you could hardly stand on the road. The tarmac was blown off, large sections of the road, just stripped away. I was driving a Gemsa truck then and waited for my companion who was in a Land Cruiser, then a juggernaut lorry overtook me and rolled off the road onto its side so it was

difficult to pass. The rescue team had a Unimuk truck, a 16-seater, but they couldn't get farther than Gríshóll and had to wait there while we ferried the people from the coach to the rescuers using the Land Cruiser and Gemsa! Oh yes, the difference can be that sharp. I remember another accident when a coach went off the road in Kolgrafarfjörður and three cars as well. The coach driver was standing by the side of the road when a jeep was blown into him and hit him with its top, but it saved his life, I expect, that there was a lot of snow, it was a blizzard. I saw the jeep after the weather died down and it had been blown two or three hundred metres, but I had the sense to drive my car into a snowdrift. And the weather down here was fine.

Once in February a westerly gale got up and some plastic roofing that was used instead of iron plating was standing up in the air after the night, like tents that had been pitched all over the roof. There was a greenhouse here at that time that exploded into atoms. The anemometer crashed so we didn't know what the wind speed was but the meter on board the ferry showed 11 on the Beaufort scale while up here at the airport, where the wind is even stronger, the meters showed only 10.

Guðmundur Lárusson
Born 1945, Stykkishólmur
Member of the Marine Accident Investigation Board, former skipper

I don't suffer midwinter depression from the lack of light, that's doubtless been bred out of me the way they can breed anything you care to mention out of people, as happens in nature. I might not be a barrel of laughs in the winter but I don't get sad either. Still, I always keep an ear to the weather. Summer weather makes me feel good, when it's warm and sunny. Calm weather at sea is extremely pleasant, when you almost need to keep your eyes closed because of the refraction of the light. But that damn fog is the worst because you don't know where you are. You can't locate yourself in the fog.

Everyone has to fear nature a bit. It can be terrible sometimes. But like everyone else, you don't let it upset you just because the weather's unpleasant. It depends so much where you are. The wind's so much stronger when you're standing upright than when you're lying down in the grass, and the difference is noticeable at sea. If you swim in the sea in a storm you can't feel the weather, because there's no wind, but the moment you come up out of the sea you feel it. A boat I was on sank once. I was just a youngster, I'd just started my life, and I found out that the same law applies at sea and out in the meadow when you lie down in the grass: the wind largely disappears down in the troughs of the waves. But it's cold to swim in the sea. It was

nasty weather, but not a tempest. A storm. A wave broke over the boat and it capsized. So there was nothing for it but to tread water and get swamped by all the waves. It was very thick ocean waves, heavy seas, and I didn't know if I'd come back up on the wave I went down on. Two of the crew died, and one was a very good swimmer. He probably got trapped under a wave and couldn't get back up.

That experience haunted me for decades. But I went straight back to sea. Soon afterwards we lost a man overboard—I was a young mate and the boat was cruising. It was one of those old herring boats with a ladder up the side of the fishing gear, which was naturally slippery from fish oil or the wet, and he lost his footing and fell overboard. He probably hit his head on the gunwale and knocked himself out because I saw him when I turned round and I went after him. You should never do that, never do anything without thinking, because I only just made it back aboard and was in a much worse state than after swimming to land the month before. And that was in summer, the previous time it had still been winter. I went after him without any means of help, although they tried to pass me a lifeline, which in fact was all twisted. It would probably have been better to tie it round me before I went, because when you're in the sea you can't see a thing. You can't see far, your eye-level is virtually zero and I never saw the man after that. Even though he definitely wasn't far away from me.

The weather's like that. If you don't fight it, you become one with it and vanish. You cease to exist if you don't show resistance and cunning. Some people are said to have an eye for the weather but that goes hand in hand with having an eye for life in general. They're doubtless better hunters and fishermen and notice more things in nature. Some dream the future and the weather, but I don't. I was sent to my grandfather at an early age, he was an island farmer and I was his handyman for a long time, I spent all the summers with him on Flatey, hunting seals and other tasks. He used sails even though boats had been motorised for fifty years. He always used sails to save petrol when there was a tailwind. And then I got to know nature and started to pay attention to things I'd never noticed.

I don't think the weather's changed. What has changed is the ships. I started as a cook and there was no sink, we just washed up in a bucket. And for a seasick cook to be peeling potatoes in rolling seas with potatoes rolling all

around him! Eating prunes was good, it was so good to throw them up! But there are just as many heavy storms today as twenty years ago.

Svanborg Siggeirsdóttir
Born 1950, Baugsstaðir, Flói
Office manager and owner of Seatours

You can always find something good about the weather here in Stykkishólmur. I've sometimes said that it's always calm here, but the calm just moves by varying amounts! The Lord above can't always please everybody so I don't get annoyed if it's not always the way I want it. That's why it's always good.

I often get very tired in sunshine, but don't speculate much about the weather otherwise. Not for my own sake, but in the tourism business it's always a question of the weather. But I don't let the weather upset me. You can't let it govern your life. Naturally you just have to dress to suit the weather, turn up the heating sometimes, but I've got plenty of other things to keep me busy. I find it incredible how many people often use up so much energy in letting the weather get on their nerves and cursing it.

I tend to remember sunny days, but for some people it's as if the weather has never been good at all. Like everywhere else, people here talk about the weather a lot, but I don't enjoy that. But it's discussed at my home a lot of course, because our cruises depend on it—and there are three skippers, so they're always speculating about it—but I say just expect the best weather, because that's generally the case.

I don't remember any incidents in particular with the weather, I just live with it. Oh yes, unfortunately I've witnessed it changing the course of people's lives close to me, but I can't fuss about it, there's no point. Like when there's been an accident at sea, which has affected me very closely. But when it's over, it's so strange, the weather might drop and immediately it seems as if nothing happened, totally calm—maybe that's the most uncomfortable aspect, how fast it happens and how fast it's over. It touches you like something strange. . . . It's so odd somehow not being able to remember the bad weather as such, then when the damage is done, it touches you how everything suddenly seemed to fall calm. I haven't wondered about that before, and can't remember if the weather suddenly struck but it happened somehow and I heard the news about it and then everything seemed to fall still, calm as a millpond, and you think it's so strange that it had to happen.

I don't let it have an effect on me, except maybe for my laundry, because the washing smells so nice if you can dry it outside. Of course it's just that the winters are a bit warmer and shorter, but, no, I don't bother about that.

Sveinbjörn Benediktsson
Born 1918, Grundarfjörður (Died 2006)
Weather measurements recorder in Hellissandur

When I was fourteen there was an accident in Hellissandur—it was 1932, the year I was confirmed. What happened was, they were going to board a boat in the harbour at Krossavík, so they put down a raft. The boat was high and dry, they didn't need a raft. But then the men on the raft, were just swept overboard in the harbour. A boat was moored there, *Skrauti*, with two men on board: Ólafur Jóhannesson and Friðbjörn Ásbjörnsson, who later became my father-in-law. They threw the men a rope but the men couldn't reach it, they went against the sea wall. It was furious weather and a search was mounted along the whole shore. That night they were both found dead under a cliff, Keflavíkurbjarg. That was terrible weather. Really awful, the worst weather I remember.

It really upset me. I thought how difficult it was for their kids: one of the men was married and had six children. My old dad owned the boat next to the man who died, the boat was called *Melsteð*, the one they were boarding. It was just like they'd been called, because they didn't need a raft to board the boat, it was high and dry. Like they'd been called.

I was always afraid of the weather if people were at sea. It was always bad to land a boat at Krossavík, which has been closed now. There was always a

tempest raging from the north when they were at sea and they had to ride the waves in. It was fun to watch the wave rolling down, then they rode it and landed safely! Then the surf might come in after them, they'd hit a wave and were swept a long way in. What an adventure! But seas like that have stopped coming now.

The weather was completely different in those days. In 1932 there was a northerly blizzard for a whole week, and there was no radio in the boats then. A boat from Grundarfjörður was out and went missing for a week, and the crew had been given up for dead. But on the seventh day a man walked in from Beruvík and said the boat was out there. The weather was fine there in the northerly wind! That's the way it can turn out. I'll never forget that.

Hólmfríður Hauksdóttir
Born 1938, Arnarstaðir
Farmer in Arnarstaðir

The most memorable weather is the summers when the grass is growing and the meadows and pastures are turning green. I think it's most important and best for farmers to have good weather at lambing time and haymaking time. Farmers need good weather in lambing time when the sheep come out with their little lambs, it shouldn't be cold then, and during haymaking when you try to get good hay, because the better and drier the weather then, the better the fodder is for the animals.

Jón Magnússon

Born 1926, Eskifjörður
Retired district commissioner for Stykkishólmur

I hear the weather the moment I wake up in bed. In Eskifjörður in 1949 was the best weather in the world, the best weather in Iceland up to this day. It was so sunny. I fell asleep and woke up with the sun at my window. That was good weather for haymaking, dry and pleasant. I refused to go to bed at night, I slept in my clothes to be able to get out into that weather as fast as possible in the mornings. I would leap out of bed fully clothed and run down the stairs and out through the door, and the whole village opened up in front of me.

Any weather whatever is always good. But there was often terribly strong weather there, when roofs were blown away and windows got broken. I remember one gusty time when something remarkable happened. A boat was in the slipway with its prow facing land. In one of the gusts it lifted into the air, turned 180 degrees and dropped back down in the same place. Everyone thought that was remarkable, because no human force could have lifted up the boat and turned it round. But I missed it. I was asleep and when I came downstairs my father was pacing the floor in the living room and constantly looking out of the windows. I looked out and saw the sky was a mass of roofing and other stuff flying about, and that sight made a great impression on me. We heard about the boat later that day and I was annoyed at missing it soar up and spin round in the sky.

Ingibjörg Katrín Stefánsdóttir
Born 1972, Reykjavík
Chief nurse at St. Francis Hospital

Once when I was eight, there was bad weather for several days, we had a power cut and the electricity was off, the weather was completely wild: it blew tiles off the roofs and I was scared. But it was fun too because people got together in the house—it was cold, they cooked on a Primus stove and drank mulled wine because this was just before Christmas. Of course I didn't drink. An electricity pylon had been struck by lightning and I saw it happen.

Then, once I was driving here from Reykjavík without wondering about the forecast because the weather was just fine until I was half-way up Vatnaleið, then suddenly there was a storm and swirling snow, a blizzard, so you couldn't see a thing, couldn't see from one marker post on the road to the next. I'd just bought a new phone that hadn't been charged so I couldn't call anyone, and I didn't have any outdoor clothes in the car, just a jacket, and if it ran out of petrol and I'd had to sleep in the car, I could easily have frozen to death. Anyway, I thought the weather was so bad they must call out the rescue team. Which they did.

Actually there's another experience that haunts me, it's rather special because the weather wasn't bad, it was a very beautiful December night with a heavy

frost and totally clear sky. The power went off in Stykkishólmur and I was a bit afraid, I went out and called my cat, because I was so scared, it was so dark. I had a cat that always came when I called it, and I stood there calling it and could tell something strange had happened, but I just stayed there looking up at the sky and there were incredibly beautiful northern lights, lots of northern lights and bright stars, and I enjoyed the sight of the skies while I was calling the cat, but it didn't come. That struck me as odd because the weather was so good, and I thought it was strange that there was a power cut, because we all know the power only goes off in bad weather or if something ices up. Later I found out that the cat had got into the sub-transformer station, short-circuited the electricity, and died. It was very sad but I still thought, because the sky was so beautiful, that there would be something very beautiful to receive him, and because it was so dark I enjoyed the sight even more. It's rare to be in total darkness.

Ólafur K. Ólafsson
Born 1956, Reykjavík
District commissioner

I spend a lot of time outdoors. I go out every day and walk a lot, especially at weekends, and the weather really doesn't make much difference, it's more a question of how you dress. I dress according to the weather. The weather never affects if I go out or want to go out. It can be just as much fun going out in a blinding blizzard as in calm sunshine, every type of weather has its own charm and the landscape always looks new even though I walk the same routes a lot, because it's the weather that determines the way I see the landscape. Whether it's wet or dry. Or the light. I find it particularly beautiful to go out for a walk in the moonlight.

If I had to choose one type of weather, I'd choose snow on the ground, sunshine and calm and frost. I think that's prettiest. And I'd choose the cold because the air is so clear then.

But I enjoy being outdoors in all types of weather. I've sometimes gone out for walks in the sort of weather where I've literally not been able to see a thing. Then I just wear skiing goggles and follow my dog, because the dog always finds its way. Some people would call that the worst weather, but it's not, because when you're outside in such wild weather you close yourself off completely. Everything under your clothes becomes a separate world.

You wonder if your feet and body and hands are warm enough and that really creates a new world for you under your clothes because you're always protecting yourself from what's outside. And I enjoy that.

I can well understand the stories I've heard about people who started seeing all kinds of spirits when they were outdoors. That's very easy, especially in the moonlight, not to mention in a lava field, there are all kinds of beings around you then. That's just the way it is. But that doesn't disturb me in the slightest, I enjoy looking for those beings in the environment. One year a boat sank out here on Snæfellsnes off Svörtuloft and I went out to Hellissandur where the rescue operation was being controlled, and there was a tempest. It was what had happened that made the weather horrific. People had died in that weather and I knew what the shore was like. It all went together, the weather and the horror.

When we lived in Ísafjörður, I was going to Reykjavík and I'd booked a flight with Icelandair. It was winter and everyone would book both with Icelandair and the little local airline, because Icelandair often cancelled their flights but the little plane went. So I had a flight booked in both places. Icelandair cancelled but the little plane left. The weather was bad and somehow I didn't feel comfortable about going, even though I'd often taken that plane in heavy storms. Anyway, I didn't go. I don't know why. The plane crashed into Ljósufjöll on that flight. And it crashed because of the weather.

Usually I don't get particularly worked up about the weather. I have memories of certain incidents which I associate with the weather and nature or landscape. Because to my mind the weather is an inseparable part of nature. Like one summer in 1999 when we were walking on Hornstrandir and stayed in a hut in Hlöðuvík. We'd been walking all day, ever since early morning, and spent the whole day in glorious weather: Almost totally calm and the sky clear as a bell, so calm that when we were up on the cliff at Hælavíkurbjarg you could almost have kept a candle burning there, it was so still. We reached the hut just after midnight and the weather was just the same, absolute calm and sunshine. We didn't want to waste our time sleeping so we stayed up until morning, watching the sun slide down gently to the sea, kiss the surface and then go back up at the start of a new day. That experience is almost unique, seeing the sunset and sunrise at virtually

the same moment. Then the next day the weather was the same, I went for a swim in the sea and somehow I merged into what I'd been watching the night before, the sun and the sea, and everything became one.

Ægir Breiðfjörð Jóhannsson
Born 1961, Westman Islands
Carpenter

I was raised in the Westman Islands where the weather's always crazy. I remember as a boy that it was fun when the dustbins were chained to the walls and if they broke loose it was like fireworks all over town. Then later, after I'd moved here to Stykkishólmur, for several years in a row around 1980 there were fairly bad southerlies, often in February, and everything here that could blow away just blew away. Whole sheds blew away, and roofs and the old football stadium stand, and an iron plate went through the window of the house next door to us and into the children's room, and landed in the crib. I was in the rescue team at that time so I was very aware of everything that could go wrong. Since then I've been incredibly on edge if bad weather gets up because I'm so aware how much can happen. It only takes one piece of plating to come loose and the roof's gone, and if you get something through your window it's danger stations. In one of those storms, a window broke and the gable of the house burst out the other side, just from the air pressure. I'm very tense and wary in that sort of weather, and can't sleep. Mainly in the southerlies, unless it's snowing.

Well, the dark isn't weather of course, but it gets me. I generally put on weight in the summer but I don't know if that's because I'm more relaxed then so I get more rest.

Warm rain, not too much but like the spring rain, drizzle, that's the best. It's very refreshing and pleasant to be outdoors in. I can't take much heat, I'm awful in other countries, if the temperature goes above thirty I'm completely done for. That sort of weather irritates me and it has to get really cold before it starts to make a difference. I generally wear shorts at home, all year round. I'm descended from farmers in crofts and I'm genetically modified to keep warm!

During my years with the rescue team after the first difficult call-out, I started getting a fear in winter of being phoned up in the middle of the night or any time at all. So it's maybe quite funny because my whole childhood was connected with an incredible amount of volcanic eruptions. I was there the night the Westman Island volcano went off and there'd already been eruptions in Hekla, Surtsey, and Jólnir. And although I was only three when Surtsey* erupted, the only image I remember from the children's bedroom when I was in the Westman Islands was when it was lit up by lightning, which was connected with the Surtsey eruption. I recall a flash: the room lit up, I can see the window and the bunk bed on one side, the proper bed on the other side, and the flash outside, which was lightning from the Surtsey eruption.

The weather's not the way I remember it in the old days, though your memory's such a clever animal, it tends to arrange things for you. But it's much more changeable and there's no snow that stays at all in winter, just bloody endless changeable weather that makes you quite depressed. Because the snow's so important, it creates so much light. If there's no snow in December it's pitch dark, but if there's snow everywhere it's bright. It makes a huge difference whether there's snow or not. You see whole communities having mood swings according to the fluctuations in the weather. People get broody and mope around, then they all cheer up again when the calm weather comes back. It's so deep-rooted, so universal, that you hardly notice it.

* Volcanic island off the south coast of Iceland that came into existence in 1963.

162

Alma Arnórsdóttir
Born 1953, Reykjavík
Accounting clerk

I always find the weather beautiful when I look outside, so I think I'm always in a good mood. I just remember as a child, in Reykjavík, going out to make angel's wings in the snow. When the big flakes fell from the sky and I used to lie down and make angel's wings. That's been with me through the years. I sometimes feel that there isn't so much snow around anymore today.

When you go up to the headland where the library is, and look across the bay in the type of weather when the sea's smooth, and all the islands come up in mirages and they glitter—it's as if they come up of their own accord, lift out of the sea, like mirages. You start thinking various things. Sometimes I could well think of walking out into the sea.

Ágúst Kristjánsson Bjartmars
Born 1924, Stykkishólmur
Carpenter

The best weather I've had was in 1939–40. It was always warm and calm and sunny then but it's varied since, I think it goes in cycles. Some winters have been tough, there's been a lot of ice and it's filled our harbour—we even had to call in the coastguard to break the ice so we could get in and out. It's been like that sometimes, but not in recent years. I have a photo showing what it was like, but that's the way it is, the weather seems to go in cycles.

Well, you're born in Iceland so you have to take the rain with the shine. Things were rather different when I was growing up, we only had woollen sweaters then—and long johns, they saved us. No, there were no anoraks, just sweaters and of course woollen underwear, that saved us. There were heavy frosts in winter and snow, like where I lived. There were five of us and we only played outdoors, more or less whatever the weather. We went skating a lot, I started skating at the age of seven.

The long winter nights today are nothing compared with when I was growing up. The darkness is the same, yes, but the lighting's different. The first thought that crossed my mind when you asked about the weather was that there used to be no outdoor lighting. Except down at the harbour,

there were three lanterns there. I suppose it was in 1925 that five or six local people clubbed together to buy a generator that had been replaced at a hospital in Reykjavík which needed a bigger one—it was brought here and used down at the harbour. I guess it powered six or seven lights outdoors. There were shops down by the harbour then, and still are, but farther up in town there were no lights.

I remember a big family that lived at Vík and the three boys went to school. Once there was a blizzard with heavy snowfall and a party was sent out to look for the boys. Their father had told them to try to reach the sea if they got lost, it wasn't far from Maðkavík, where they could follow the shore all the way to Vík. And they were found on the way, not far from Dauðsmannsvík.* We were always afraid there, because seven people died there once. Their bodies were all found in the creek and they were taken off and put in the hay in the barn at Borg. But the next morning when they went to fetch the bodies, the woman was out by the door, she was pregnant. So she wasn't dead that night and had crawled all the way out to the door. In those days they didn't check properly to see if people were dead.

* "Dead man's creek."

Ingibjörg Árnadóttir
Born 1923, Grundarfjörður
Housewife, handicraft artisan

If the weather's bad it has a nasty effect on me. My husband was a
fisherman for most of his life and so were my brothers, everything's
been connected with the sea and naturally that causes worry about the
weather, especially if it's windy, a gale. Once the roof was blown off
the house I was raised in, this was in 1931. Since then I've always had
a fear of the weather, it haunts me if it gets windy or something like that.
The house had to be rebuilt. It was a little timber house and Mum and
Dad lived there with their six children, grandma and granddad were
there too with their daughter and son-in-law. Dad wasn't at home and
I remember that while all this was going on, Mum had to go outside and
this young man who lived at the other end joined in to help them hold
the house down. That moved me so deeply that I'll never forget it. In the
meanwhile a windowpane broke on our side of the house and as a kid of
nine I had to stuff a quilt into the hole in the window to keep it in place
until they came and could board it up. Since then I've always been afraid
of gales. Dad came from Stykkishólmur with two men who lived out there
and came back to an empty house, no one at home. We were taken to the
nearest house, called Fagurhóll, which was the closest place—everything
was buried in snow and we had to walk there.

Another time my old Dad was at sea, I was a child although I was older then, I think I was eleven or twelve years old. The boat he was on went missing and nothing was heard from them for two days and nights. We had no idea about how they'd fared, and then they turned up. This was in Grundarfjörður. They just had to wait for the weather to die down, found a sheltered cove but couldn't let anyone know about them, there wasn't radio in those days or anything like that.

I can't say the weather's changed my life. No, not like that, but one of my brothers drowned, it wasn't so many years ago. The boat he was on went missing.

Rebekka Bergsveinsdóttir
Born 1934, Neðri-Gufudalur, West Fjords
Farmer

I've had various jobs in my day, delivered the mail for several years and worked as a cleaner in Reykjavík where I lived for many years, then I ended up out here in the west and have been a housekeeper on a farm for twenty-two years, a farm which is very small and crummy now. But talking of the weather, it's affected me enormously, probably most when I was delivering the post and I woke up every morning and had to go out whatever the weather. During those four years there were only one or two days when we didn't go out. One was called the "big roof storm," it might be long forgotten now but it was probably around 1966–70. I saw the roof of the Hekla car showroom lift up in one piece and drop onto all the flashy new cars that were in the yard at the back.

Of course I grew up being very dependent on the weather, I was brought up in Aðaldalur where people tended to look at the weather every morning and speculate about various things connected with it, especially in the summer. It was always a question of dry weather and the like, because the weather isn't pleasant in Gufudalur. There was no road then—it wasn't built until 1952—and all the provisions were brought in by sea, so people often wondered if it was sailing weather. I was born in a turf farmhouse, but it was a big, good house, an old vicarage in the style of that time.

Maybe they were dying of boredom with no television. Everyone listened to the radio a lot, I remember the days when Jón Eyþórsson used to read the weather reports, except during the war, weather reports were simply not broadcast during the war, so people maybe read more from the clouds. My late father, Bergsveinn Sveinsson, would go out in the mornings and shake his shoulders when he came back in and maybe say "Well, it's definitely going to get worse, because it's not getting any better." That's something I remember as a child, the weather was always said to be getting worse. But I think the most memorable incident while I lived back home was in the winter of 1949. My mother fell ill and was sent to Reykjavík by plane, and it was crucial whether the weather was fit for traveling that day because she was transported in a very strange way, on a sledge that was pulled by a horse out to the edge of the sea ice. Captain Jóhannes Snorrason landed a flying boat from Ísafjörður and took her on a stretcher into a plane full of passengers. Jón from Skálanes had a little rowboat with a motor and took her aboard the plane single-handed and the weather was good that day, no question of that, otherwise it wouldn't have been possible. But in 1949 there were dirt storms in February and March almost every single day, that's the closest I've ever been to suffering from depression, because I was alone with my father and one brother, I was only thirteen or fourteen and was trying to cook. I learned to bake bread and use cookery books and the like, although that's nothing to do with the weather. Anyway, the storm beat against the windows and the roof of the old living room and I remember so clearly how dad said: "some people believe it will just go on like this and lead to an ice age." But it didn't, because on June 17 that same year, that was so memorable, it was the first thaw of the year and when it thawed there was ice all over the fjords and snow over all the slopes, none of the roads were fit for traveling, not even the horse tracks. I was sent off with the old horse pulling a cart to Gróunes to fetch a halibut that the coastal ferry had left behind there. That was the custom, goods were sent from Flatey and left there to be collected either by boat or horse. The summer was very reasonable then, although the weather had been bad, the snow had been so heavy that it spared the grass and the spring was fair even though it began so late.

Another thing though is that all these years since then we've spent a huge amount of time in the West Fjords, you could say that every year we go half a century or so back in time, because we rent the old farm

at Langibotn in Geysisfjörður and no road has been built there yet and probably never will be, there's no television reception, though we have a phone these days and have always listened a lot to the radio. But it's still the weather that we worry most about, every morning when we look out it's generally "What's the weather like?" And the weather there can be terribly nice and warm, the farm is incredibly sheltered and well grown. I was last there this summer in twenty-seven degrees like everywhere else, when the sea looked like a seething potful of porridge. You often get what the people from Arnarfjörður call "inland calm," it might be sunny and calm in the valley and then the wind suddenly gets up and blows in and changes everything so you can't go to sea. It can be like that day after day for days on end and often makes us worried about how the weather can treat people.

One autumn I waited there after the adults had left and was by myself with a big brood of children, including a baby that had just turned one year old. I was waiting to be collected by boat but it happened that every day when I got up it was windy, strong winds both on land and at sea, and in the end I ran out of oil and had to set off over the mountains with the children, I couldn't stay any longer. What saved me was that a man was coming down the mountainside, the poor baby was put in a bag and this elderly man who was just on a visit there carried it on his back. We climbed the mountain and it was so windy that we had to crawl—so don't say we're not dependent on the weather.

Here is the windiest place in Iceland, it has the sort of weather where you can fall asleep in a nice calm but wake up with a gale blowing from the mountains, and it's no ordinary gale, it doesn't leave a stone unturned. Once some people went outside to the sheep sheds and took a rope with them, but spent the next hour hanging onto the rope and couldn't get back in. Seriously, they reported it on the TV as a joke, but it actually happened. The tarmac was blown away, which was a sin because the road had just been surfaced and the tarmac just rolled up. It really was the kind of gale when the gravel just gets blown everywhere, it literally piles up in drifts. It's not a dirt storm, just gravel that swirls away, all the anemometers almost go off the scale in the worst gusts, which isn't strange of course. It's the consequence of the location of this place.

I'm not usually apprehensive about the weather, although I think it comes out in this obsession of mine about iron plating not being firmly enough nailed down, objects not fixed securely enough, nothing being loose that could blow away or cause damage. But sometimes I've been unprepared for such weather. The last time was this summer when that kind of weather broke completely without warning, it started by tearing down the fences and a little plank in the yard, which didn't look at all harmful, hit the laundry room window and broke it. Actually I think deep down inside it's a fear of winter itself, but that's been wearing off because we've had several winters now which have been really good. Of course we haven't got a pledge in writing today that next winter will be good, but we can still hope.

Helga Kristín Sigurðardóttir
Born 1990, Stykkishólmur
Student

I sometimes think about the weather but only if anyone wants to meet me outside. I know someone who's afraid of the weather and gets hot sweats if he sees the weather's bad outside. That doesn't happen to me but I generally just hang indoors if the weather's bad.

I remember one particular New Year's Eve when the weather was so bad we couldn't set off fireworks. Everyone just had to save their fireworks for twelfth night.

Jónína Kristín Jóhannesdóttir
Born 1923, Hnúki í Klofningshreppi
Farmer in Hraunhálsi

I've spent part of two winters in Reykjavík and I don't like it. Everything's dreary, it's dead boring in Reykjavík. I've only been there because I'm in such bad shape that I can't work.

I used to keep sheep here but I can't look after them now, that's why I go in the middle of winter, but I always spend the summer here, come straight back. I leave when the birds fly south in the winter and come back with them in the spring, that's what I say.

But now I just can't do anything. In the past I'd go outside in all kinds of weather. While I kept my sheep down in the sheds over there I sometimes came and went and waited, thinking the weather might improve a bit when there was a northerly blizzard. Once I thought I wouldn't be able to find my way but I chanced upon a washing line post that was here, you couldn't see a thing. It was a total whiteout, absolutely crazy weather.

You just had to struggle on through it, there was nothing else to do. But naturally it must be awfully good for people who have the time to go out in the nice calm and sunshine in summer, sunbathing like the young people call it.

Bad weather is a sheer northerly blizzard when you can barely use your eyes to see where you're treading, you can't see a thing, and the snow beats into your face. Of course I dislike that but it never lasts for long. But in the old days when I used to mow the grass with a scythe, I enjoyed most of all going out in a breeze with drizzle and sunshine, that was wonderful.

Storms like you got north of here are the worst kind of weather, they roared over the island. You got soaked if you didn't wear a decent coat, going from the house to the lighthouse. I often had to go and dry the lights, the glass on them, so they could be seen as clearly as possible. Then maybe there'd come such a huge northerly gust up that only hill on the island that you got soaked over that tiny distance. The northerlies were the worst there, of course the wind was nasty from the west, north and northwest, the waves used to break so much.

Here the southeasterlies are by far the worst. The northerlies, they're all right, although sometimes they're nasty in one way: I've noticed several times that in a sharp northerly the sea sprays up here over the cabbage and flowers and the like. Once, many years ago, a visitor dropped in for coffee and left his car outside. Our hay cart was standing outside and no one paid any consideration to it of course, but when they went out again the cart had been blown on to and over the car.

I feel the weather's improved a bit in recent years. It doesn't get as wild as it used to. One Christmas Eve, in 1994 I just . . . I just lost my house. The old house was here then and you could walk straight out, and when I went out and was going down the steps I just got stuck, there was a total blanket of snow. There's just the occasional incident that I remember like I said before, I just went back inside to dress better and set off. I had to walk all the way down to the sheep sheds but I just couldn't move my legs.

We used to sell milk and when my husband died I was left here by myself. Once I remember there was a huge amount of snow and I set off with the milk churn on my back with my dog in front of me and she just swam through, it was awfully good to have the dog leading the way. Then the next day I had to go out again and saw my neighbour taking his milk out, and he came over here and caught up with me.

I was only half-way down turning off the road by the time he was—he was much faster than me in his car—and he said "I can't watch that, Jónína, let me have the damn churn."

I remember at my grandparents' farm for instance, when we'd finished haymaking on the field we used to go out beyond it to the meadows. Once we were raking the hay together and it was nice weather, sunny and dry, then suddenly we heard a rustling sound and everyone looked up, me and the woman who was raking with me, and suddenly the hay swirled up right in front of us like a jet into the air. That was how the wind could come off the mountain, down Fábeinsdalur and down to the fields and meadows. Just like a whirlwind, it was the same at Hnjúkur, it struck the farms there under Klofningshyrna, just think of that happening, I was raking hay in reasonable weather and then suddenly a jet of air would just rise up even if there wasn't much wind around me. I remember this when I was a young girl staying with my grandmother, I found it so terribly strange. I don't recall it myself, but I was told later that I ran in crying to my grandmother and told her to look after me because the wind could snatch me away.

Egill Egilsson
Born 1991, Stykkishólmur
Student

The best weather is the weather I can play basketball in. The worst weather is when I can't play basketball, I think.

Margrét Ásgeirsdóttir
Born 1955, Djúpavogur
Postmaster

I started working for the post in Hveragerði when I was twelve. Once I was delivering the mail in a big snowstorm and blizzard and I took a shortcut in the village. I was so tired, I'd almost finished and I thought to myself, I'll just have a quick lie down here. And I fell asleep. Then I woke up with a bulldozer clearing the snow close by and it had drifted right over me. That's how people freeze to death, but I woke up. Afterwards I started thinking about what would have happened if I'd been somewhere else with no traffic. My father told me that that was one thing you must never do. But walking in a snowstorm, you just feel tiredness coming on and oh!, it's so nice just to lie down in the soft snow.

MORGUNBLAÐIÐ NEWSPAPER

(1998–2003)

Note on Texts

The texts included in this section were written for
Morgunblaðið, Reykjavík. At the time, *Morgunblaðið* was
Iceland's only nationally distributed daily newspaper.
 "The Nothing That Is"
 "Notes on Icelandic Architecture" (Excerpt)
 "One Hundred Waterfalls, Five Hundred Jobs"

Iceland's Difference
A series of 23 visual editorials. Weekly publication began
on April 6, 2002. Each installment occupied page 16,
the last page of Lesbók, the weekend culture section.

All texts were published in Icelandic. Translations by
Fríða Björk Ingvarsdóttir.

THE NOTHING THAT IS

I grew up with trees. I count them among the most important things in my life. But oddly, when I come to Iceland with its treeless landscape, I never miss them. Over the years of travel here the open, unobstructed views of the island have become very important to me. These views are the trees of Iceland. Because one of the great qualities of the tree is its way of relating things: the earth to the sky, the light to the dark, the wind among its leaves to the stillness that surrounds it, the small spaces within the tree to the vast spaces it inhabits. Here in Iceland the view takes on this role and in doing so expresses a wholly unique sense of place. The weather is a big part of this sense of place and a view here is never without it. It allows a glance at the rolling past and sometimes what's to come. The view contains the distant and the near often with equal clarity. It lays out the shape of the planet with an expansiveness and transparence that exists in few other places. It holds you in a solitude that enlarges you. The view relates you to a world that is mostly a world of natural things: rocks and vegetation, and water, complex, multifarious things that are also remarkably young.

I grew up in New York City and its early suburbs. My first trip abroad brought me to Iceland in 1975 when I was nineteen.

Since then, the roads, especially rough (but having a way of keeping a traveler in close contact with the land both physically and psychologically) have been primed for faster, more convenient travel. With the paved road and accelerated rate of passage I notice my relationship to the land becoming more distant, even abstracted. To maintain contact with it requires greater responsibility on the part of the traveler. This seems a small price to pay for the extensive quality-of-life enhancements such development brought.

Among the many advantages that Iceland enjoys is its unique position in

history relative to those of other modern cultures. Because Iceland has experienced delayed economic development the country is fortuitously out of sync. You are out of sync because your environment, unlike those of other modern societies, is still intact. This places the country now, at the end of the second millennium, in a critical position to observe the destruction that other societies have brought upon their environment through flawed and unchecked development and exploitation of natural resources.

Iceland is in a position to bear witness to these dubious fruits. And with this knowledge it must question the extent and nature of development it wishes to pursue. Unlike other cultures whose major development is yet to come, Iceland does not suffer from rampant illiteracy or ignorance brought about by a censored press. You do not suffer pervasive poverty, overpopulation, or recurring natural disasters in the form of drought or floods or unchecked disease.

Up until very recently it seems that exploitation of natural resources has been limited by the size of your economy. But now, as the economy grows, society is more willing to consider ever more invasive methods of expansion in the service of ever-increasing levels of affluence. And with this new potential a greater willingness and most definitely a greater technological capacity to alter nature is pressed forward as a necessity.

As a foreigner I have watched with admiration Iceland's persistent refusal to allow foreign influences to compromise your language. I have admired the extraordinary literature that you have invented and that is such a profound part of your identity. I have also admired your early architecture and indigenous building, much of which is unique to your culture. And then there are the many enlightened aspects of your social culture, among the most notable of which are the pragmatic tolerance of intimate union and the responsibility taken for its outcome.

But now when I come to the island I wonder whether you see the fast rate of change that your society has undergone, especially in the last fifteen years, and how it now begins to affect the fragile ecologies that surround you. The nature that surrounds you is especially fragile and especially glorious because it is unusually young. As a result, your capacity to alter and destroy nature is greater than ever before.

Modern society has experienced a seemingly uncontrollable appetite for consumption, well in excess of individual need. The resultant overexploitation of natural resources has destroyed many underlying organic equilibria. This fact is now experienced in part with ever more frequent catastrophic events of weather as well as pollution, in the form of both toxins and invasive manipulations of

the environment. Iceland is in a unique position to make choices that will bear profound influence on your identity as a people. It is a choice that must reflect your knowledge of other cultures and how they have, initially through ignorance and then through wantonness, destroyed their environment. In the United States, for a large portion of the population one's health is no longer one's own. It is degraded by toxins that though unseen are so pervasive they cannot be kept out of the body. These are choices that must assess the real value of development not just in physical and quantitative terms but in spiritual and psychological terms, as well. Many post-industrial—and/or overpopulated—countries have polluted their waters, their land, and their air, in some places to an extent that makes them uninhabitable. It is a pollution that is toxic and most often irreversible, a pollution that has deeply undermined quality of life. It is also a pollution that destroys humanity even as humanity fights for the right to pollute.

Excessive development and the overuse of natural resources is a choice. It is not based in necessity. Development that results in the introduction of pollution to the Icelandic environment cannot be regarded as a viable option. It will ultimately, though perhaps not immediately, degrade it. Today, when you look out over the ocean that so fortunately surrounds you, you have the knowledge that other cultures may not have had or did not care to respect. You have the choice to implement the use of renewable resources to sustain your economy. You have the choice to utilize less invasive methods of production and the choice to produce things that do not result in irreversible damage to your environment.

This essay is motivated in particular by my fear of the loss of the Highlands. But as I write I see that it applies to the island's ecology as a whole. With each visit to Iceland I become ever more anxious concerning these issues. Yesterday as I was driving out of Reykjavík I was shocked to find myself comparing the view out my window to that of New Jersey in the early sixties. As an artist, to me Iceland has borne a deep influence in my professional development. And as an artist, this is a deeply personal matter as well. Over the years I have felt the necessity for my returns here growing greater still.

Which brings me to the crux of the matter, the potential loss of the Highlands. It won't happen right away. First you will build a dam in some remote corner. (In the belief that you can power X, Y, and Z industries, in the belief that you can expand your economy and increase your affluence. You won't concern yourself now with the fact that these industries will most likely pollute the water and the air. You won't discuss the fact that this is really the first of many dams.) Then you will flood a valley. (Never mind that it is the only valley like it in the world. Perhaps you will convince yourself that the resulting lake has its own

beauty, perhaps even accept it as more nature—even though you know it is really artifice.) Along with the dam will come the roads and other civil infrastructures. (You will drive these roads and imagine a truly wild place—perhaps one that no one has ever been to before—but in reality these roads will turn the whole of the interior into a parody of itself. Now it is merely more domesticated space.) Along with the roads comes greater access for everyone, and along with this access, a level of use that will quickly dominate and subdue the wild and unknown.

The Highlands, while often referred to as a vast, empty space, is neither vast nor empty. The American poet Wallace Stevens names precisely what the Highlands is so profoundly full of in his poem "The Snow Man." He writes:

> For the listener who listens in the snow
> And nothing himself, beholds
> Nothing that is not there and the nothing that is.*

In my experience the Highlands is one definition of the nothing that is. And the nothing that is synonymous with the real. The real cannot be mitigated without destroying it. The Highlands is not for everyone. To enhance its accessibility is to deny what it is. An individual who wishes to travel the Highlands must be equipped both psychologically and physically—and not the other way around. The Highlands is a desert, it will take your measure. It cannot be made into a place for the casual visitor.

Your Highlands, while lauded as the single largest unexploited block of land in Europe, is, relatively speaking, tiny, not even the size of Ireland. Once you have compromised it, in a matter of one generation or two at the most, your identity as a people will be altered. Iceland will become a place dominated by human presence. The balance of identity will tip—away from the majestic solitude of the interior—away from a place largely unoccupied, uninhabited, unaltered—away from the possibility of a place more clear and clean and pure than not—away from a place that expresses vastness and absoluteness, and all that exceeds us— away from a place that is exquisitely distinguished simply in being what it is— away from the many, many things I come to this island to experience. These are the things Icelanders have been nurtured on, perhaps unknowingly, that give this culture its remarkable difference, and its utterly unique sense of place.

With this change Iceland will simply become more like the rest of this mostly compromised world—dominated by a humanity that can only value nature as something to be exploited.

Iceland has a choice. The destruction of the Highlands is not necessary to

your cultural and economic development. You do not need its resources to live comfortably. Encroaching upon its fragile ecologies even to what is erroneously perceived as a small degree will destroy it. It won't necessarily be an obvious change, but it will be radical and it will be irreversible. It will weaken your identity as a people by taking away from future generations' unaltered and unoccupied land that exists today in a scale that expresses and sustains the power and presence of non-human things.

Published September 6, 1998, *Morgunblaðið*, Reykjavík

* From Wallace Stevens, "The Snow Man," *The Collected Poems of Wallace Stevens* (New York: Alfred Knopf, 1978), pp. 9–10.

NOTES ON ICELANDIC ARCHITECTURE
(Excerpt)

Two Buildings in Reykjavík

SUNDHÖLL REYKJAVÍKUR 1929–37 (Guðjón Samúelsson)

This building, deeply appreciated by its devoted regulars, offers what is perhaps the most fascinating architectural experience in Reykjavík. In the pool hall are all the simple delights of an open and well-proportioned space. The tiling of the pool in Iceland's favored green is a satisfying detail and so too are the vertical clerestories of small-paned windows that light the hall with a distilled and shadowless light all day long. Down below: for women, over: for men, are the locker pools—literally a collection of lockers and changing rooms. Here is a structure disguised in the language of the familiar and the everyday. But this is only a disguise. Featured in its labyrinthine floor plan is a network of doors that are simultaneously open and closed. This may sound like a simple matter but they present a beguiling paradox—one that even as I stand in front of them eludes my grasp. It's impossible to imagine where a network of such doors can lead, but as in a game of chess, it is too complex and the options too many to be known except through the play.

The tiling of this network of rooms and corridors is simple. In fact the white horizontal tiles that cover the walls and halls are plain as tiles go. But it was with some surprise when I recognized that these tiles covering the entire structure both inside and out formed one surface; for there are no edges in this collection of spaces, no simple planes intersecting in lines. Instead the corners, interior, and exterior, are melded into a single curved surface as are the top and bottom of this structure. Inside and out are fused into a single, unending form. Intensifying this mobius of tactile and spatial continuity are the mirrors that reflect and compound the complex symmetries of the locker pool.

And then there are the peepholes: a peephole punctuates each locker door

at eye level. Through it you see the next peephole and door and hall and on and on. Here in this net of intricate and uninterrupted visual flow is an expression of (mostly) unseen but sensible infinities at least one of which is the voyeur's labyrinth.

MELASKÓLI, REYKJAVÍK 1946 (Einar Sveinsson)

Here is a school whose organization and structure emphasizes the importance of the unknown and the unseen and the roles they play in education. In addition to being a school, Melaskóli features the primary entrance to Iceland, the country, and the culture. Here I am speaking of the maze and fold posing as an entrance that every child educated in this building must enter and navigate daily. In the process of negotiating the maze comes the experience of play, of endurance, of the unknown. Once the maze has been negotiated, I imagine through hide and seek and other games of revelation, you enter the main building. Gently curving halls create a sense of anticipation as you wind your way toward an end that remains mostly unseen. And then the doors through which you enter the classrooms, curved like the halls themselves and giving each child who opens them a direct and visceral sense of the place they are standing in. In this inarticulate and sensible knowledge is an awareness of how the parts communicate the whole. The metaphor the building's design so inventively engages is of the act of seeking as an act of learning.

Humanism in architecture is often expressed in a reasonable and measured use of scale. Here in Melaskóli it is a scale that is large and spacious enough to sustain the possibility of adventure, so essential to any learning process, and yet small enough to avoid intimidation.

These not-so-hidden treasures offer, from a social and architectural point of view, powerful places in the way of learning environments. It is hard to separate the qualities of these structures from the future humanity of its users and graduates.

(1999)

ONE HUNDRED WATERFALLS,
FIVE HUNDRED JOBS

A wise man once said that next to losing its mother, there is
nothing healthier for a child than to lose its father . . . parents have
. . . more need of children than children have of parents.*

These words take on new meaning in the aftermath of Iceland's commitment to bringing large-scale industry and major geologic alterations to the island.†

To believe that the ecological consequences of damming large and powerful rivers are small and containable is tragic. To believe that water will flow enough like the nature they represent, when regulated by infrastructure, is unfortunate. To believe that altering the landscape in such a radical way can nevertheless result in a look-alike-nature as complex and balanced as the original is wrong.

As an American, it is bewildering to me to understand why Iceland, one of the wealthiest countries per capita in the world, with low unemployment, and one of the cleanest, most ecologically intact *modern* countries in the world, is *choosing* to take on a strategy that will ensure the loss of these qualities. First by defacing the area of Iceland that goes to the heart of the nation's identity, and second and most importantly, by setting a dangerous precedent for further harmful development.

It is 2002 and so far Iceland has managed to sidestep these unhealthy, inimical options. Introducing them now reveals exactly how far behind the rest of the modern world Iceland really is. Iceland has had the opportunity to see where these unimaginative strategies have taken others. And it is clear that the short-term gains are grotesquely outweighed by permanent and irreversible losses. The American landscape is a litany of these losses: industrial waste, ecological destruction, and environmental pollution. (Witness New Jersey, presently home to some of the highest cancer rates in the United States; witness the Everglades in Florida, home

to one of the largest reengineering-of-nature-projects in America, which are now not expected to survive as wetlands, despite the investment of *billions* of dollars to reverse the damage; witness the Gulf of Mexico, now known as "the dead zone," as fish can no longer survive in its waters; and witness the damming of the Colorado River, considered by many to be the largest ecological disaster in American history.) America is the landscape to learn from. But instead Iceland has chosen to become the first *modern* society to reverse the clock—having evaded industrialization all these centuries, Iceland will become the first *modern* country to go industrial. Even more disturbing, Icelandic politicians have additionally arranged, at no extra cost, to trade on Iceland's relative freedom from pollution as the basis to produce even more pollution than would be acceptable by international standards. Iceland now has success in welcoming the dubious industrial opportunities that poorer, more unstable countries have turned their backs on. It appears as though Iceland has literally decided to go backward.

Iceland is still a clean country in a world increasingly polluted, and although hydropower is "clean," smelters and industry in general are not. Even the image is dirty. I ask myself, "Why is Iceland choosing to introduce industrial presence and industrial pollution to the island? Why is Iceland willing to aggressively alter its landscape and damage its fragile ecosystems? Why is Iceland freely choosing unnecessary civil infrastructure, having witnessed the irreversible damage industrial societies have brought upon their environment and ultimately themselves?" I ask myself, "Why do Icelanders, an educated community, imagine that they can escape the damage other modern cultures have not?" And finally, "Why are Icelanders, who enjoy a quality of life *based in the integrity and unique wholeness of their landscape and the purity of its resources*, willing to risk its destruction?"

Destruction is an unacceptably benign word to use in this context. A more accurate word is mutilation, specifically self-mutilation. What Iceland is poised to do in the building of this dam and accompanying network of roads is an act of self-mutilation. Perhaps Iceland's recent freedom from poor housing and bad weather still provoke strong responses, demanding development at all costs. But the reactionary impulse to disregard or destroy things related to this past domination is highly self-destructive.

The psychological, spiritual, and physical benefits of respecting the integrity of one's environment are immeasurable. But it's not just in the fact of having it, but in taking efforts to sustain it as well. Anyone who can imagine becoming a parent must also take responsibility for ensuring environmental integrity. Failing to protect the fundament, judged in the light of your children and your children's children, is failing to value the health and spiritual well-being of your descendants.

To date Iceland has done relatively little damage to the environment, not out of respect for it, but because there are not enough Icelanders to keep pace with the world in its ruination.

In observing how bewitched Icelanders are by America, and the questionable influence it exerts in this country, I would like to mention how proud I am to have grown up in America, proud of the incentives given to encourage invention via capitalism and of the freedoms that enable individuality of all kinds to flourish. But of late I have grown deeply ashamed of being American. It's not simply the widespread disregard of nature, whether logging the last remaining thousand-year-old trees or willfully polluting whole landscapes with heavy metals, organic compounds, and innumerable other toxins. It's not only the insatiable greed scaled beyond historic precedent, but unbridled consumerism that takes the form of mindless materialism. The further a culture goes toward destroying the balance of its natural setting and its relation to it, the more profound the need to mask, deny, and substitute for it becomes. This is one basis for ever-increasing levels of consumption, one that bears no relation to need or affluence. It is compensating for unspeakable losses.

Looking from the outside in, I observe how sadly lacking Iceland is in basic self-respect, self-respect that would encourage the nation to look critically at the world and use it as a lesson for how things could be different; self-respect that would enable the country to take the risk of being different; and self-respect that would ask the nation to find solutions based in the particular and distinct qualities of the Icelandic people, not solutions that are wholesale imitations of other cultures' irreversible mistakes.

At this time, the extent to which many, perhaps most other nations have thrown their environmental heritage to the wind, such an attitude is appalling. It shocks with the degree of naïveté it reflects. I want to believe it is ignorance but island isolation disappeared long ago. The fact that Iceland has not experienced the consequences of such wanton disregard does not mean that the nation won't wreak the same havoc in pursuing the same directions. But one very important difference sets Iceland apart: Iceland has a choice. So one hundred waterfalls disappear and five hundred jobs appear. That is five jobs for every waterfall. And that's what I call the cheapest date in any town on earth. This is an unconscionably high payment (and with national assets) for such meager return. It is one thing for competitors to underestimate one's value, but what does it mean when elected officials have so low an estimate of their nation's worth?

Iceland will never be a world-class player. Its scale and beneficent freedom from fossil fuel resources prevents this. All the more reason to play by your own

rules. Iceland has survived and thrived on its own terms for so long. Why stop now?

Parents and politicians unwilling to find real long-term solutions to economic adversity cannot continue to hide behind their children's future as a reason for destroying the finite and vulnerable riches of today.

In the opening lines from *The Fish Can Sing* quoted earlier, Halldór Laxness was speaking of continuity. Later in the book he speaks of the tick-tocking of the clock at Brekkukot. Laxness quotes the clock: "et•ERN•it•Y—et•ERN•it•Y—et•ERN•it•Y."‡ But here in Iceland you have reversed the syllables. Iceland now looks forward to a dirtier, sicker, and less Icelandic tomorrow.

Welcome to Iceland, 2002.

Published July 29, 2002, *Morgunblaðið*, Reykjavík

* Halldór Laxness, *The Fish Can Sing*, trans. Magnus Magnusson (London: Harvill Press, 2000), p. 3. (In Icelandic *Brekkukotsannáll*, 1957.)

† In 2002, the Icelandic government and Alcoa, the world's largest aluminum company, negotiated terms for the construction and operation of Iceland's largest energy project, the Kárahnjúkar Hydropower Project, to be built in a region claimed as Europe's second largest wilderness area. The enterprise would dam and divert two of the region's largest rivers, funneling water from man-made reservoirs into a single underground power station. The project was heavily criticized for its environmental impact during planning and construction. Between 2002 and 2008, five dams and three reservoirs were created; the hydropower plant became fully operational in 2009. See Donald G. McNeil Jr., "An Icelandic Battle of Wildlife versus Voltage," *New York Times*, July 16, 2002, section A, p. 1.

‡ Halldór Laxness, *The Fish Can Sing*, trans. Magnus Magnusson (London: Harvill Press, 2000), p. 5.

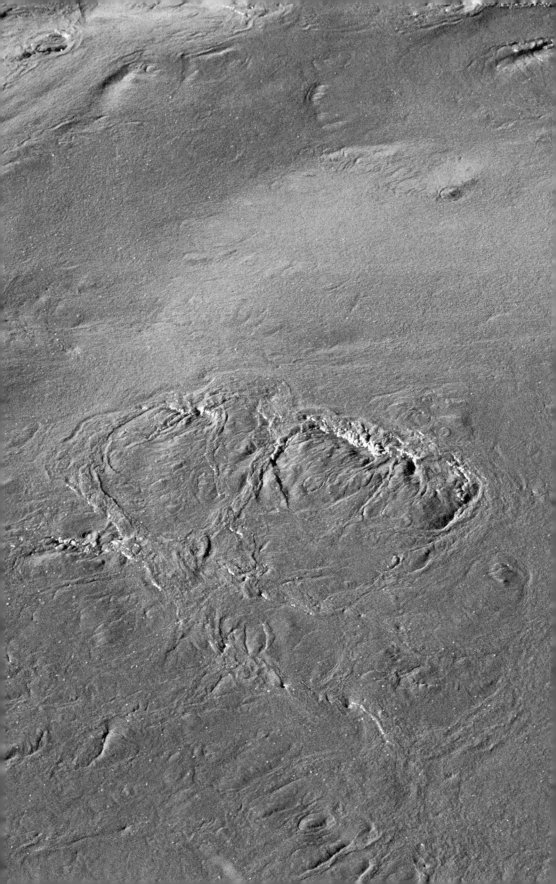

ICELAND'S DIFFERENCE

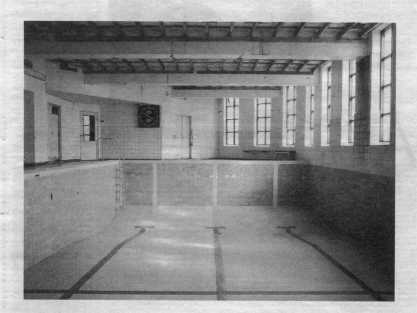

SUNDHÖLL, LAUGARVATN, 1991: Þegar ég gekk inn í þennan sal í fyrsta skipti snemma á tíunda áratugnum vakti gáskinn sem þar ríkir fögnuð minn. Ég gerði mér í hugarlund þann munað er felst í því að alast upp í námunda við slíkan rausnarskap. Upprunalega byggingin var hönnuð af Guðjóni Samúelssyni á árunum 1928-9. Þessu rými var aukið við nokkrum árum seinna. Eitt sinn var þetta góð kennslulaug, kunnáttusamlegt og lísrīkt* framlag til menntunar Íslendinga; síðar bygging með sögu, tilfinningu fyrir umhverfi og menningu; og enn síðar, árið 2000, var hún jöfnuð við jörðu. Byggð var stór sundlaug rétt hjá, árin 1991-92 þar sem hægt er að stunda heilsusamlega sundiðkun utanhúss, en hún er hversdagsleg útlits og skortir bæði sögu og tengsl við umhverfið. Önnur kemur ekki í stað hinnar. Það er þörf fyrir báðar, það hlýtur að vera svigrúm fyrir báðar.

*Sjá Sundhöll Reykjavíkur eftir Guðjón, þar sem notaðar eru flísar í þessum sama eftirlætis-ísgræna lit Íslands.

Þetta er fyrsti hluti flokks sem í heild ber heitið: *Iceland's Difference (Sérkenni Íslands)*. © fyrir ljós-mynd, 1991, og texta, 2002, Roni Horn.

SUNDHÖLL, LAUGARVATN, 1991: When I walked into this room for the first time in the early 1990s I took great delight in its playfulness. I imagined the pleasure of growing up in the vicinity of such a generous offering. The original building was designed by Guðjón Samúelsson in 1928–29. This space was annexed some years later. Once a learning pool, a crafted, colorful contribution to the education of young Icelanders;* more recently an historical structure with a sense of place and culture; most recently, 2001, demolished. A large swimming pool was built nearby in 1991–92 providing for a hearty out-of-doors swim but is generic and institutional and lacking any sense of place. One does not replace the other.

(No. 1, *Iceland's Difference*, April 6, 2002)

* See Samúelsson's Sundhöll Reykavíkur, utilizing the same favored-green-of-Iceland tiles.

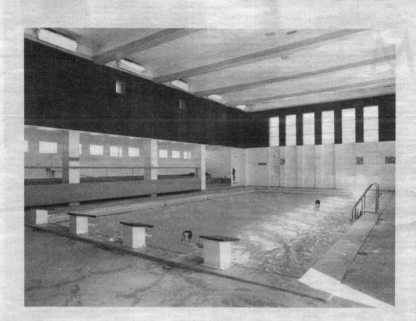

SUNDHÖLL, SEYÐISFJÖRÐUR, 1997: Hönnuð af Guðjóni Samúelssyni seint á þriðja áratugnum. Hér erum við komin aftur til ársins 1997, seint á sólríku sumarsíðdegi. Nokkrir, ef til vill innfæddir Seyðfirðingar, njóta þess að bregða sér í hlýtt vatnið. Ágæti þessarar laugar er að mestu enn fyrir hendi innandyra, en hefur lotið í lægra haldi utandyra. (Til þess að fá hugmynd um hvernig byggingin var upprunalega að utan má ímynda sér aðeins hógværari útgáfu af Sundhöll Reykjavíkur.) Einhvern tíma var byggingin klædd í báraðál til að hressa upp á útlit hennar. En mannvirkið sjálft grotnar niður þar undir. (Það grotnar niður á meðan þú ert að lesa þetta.) Við innganginn eru dældir áranna skráðar í þunnan málminn: högg og spörk. Ef til vill eru þau vísbending um gremju og reiði yfir niðurníðslu fallegrar byggingar.

Þetta er annar hluti flokks sem í heild ber heitið: *Iceland's Difference (Sérkenni Íslands)*. © fyrir ljósmynd, 1997, og texta, 2002, Roni Horn.

SUNDHÖLL, SEYÐISFJÖRÐUR, 1997: Designed by Guðjón Samúelsson in the late twenties. Here we are back in 1997 one sunny summer afternoon. A few, possibly native Seyðisfjörðurites are enjoying the warm water. This pool's virtues mostly still intact on the inside have all but disappeared on the outside. (To get an idea of the original exterior, imagine a slightly less elegant version of Sundhöll Reykuvíkur.) Some time ago the building was sheathed in corrugated aluminum to maintain appearance. But the structure itself decays beneath it. At the entrance the thin metal sheathing records years of dents: punches and kicks. Perhaps expressions of frustration and outrage?

(No. 2, *Iceland's Difference*, April 13, 2002)

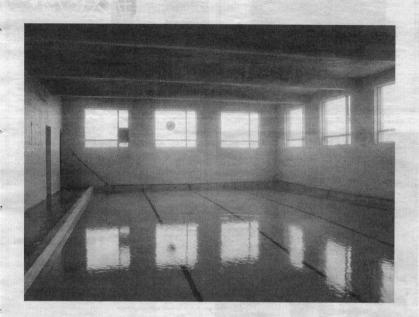

LAUGAR, VESTFIRÐIR, 1991: Þessi laug skipar sérstakan sess í lífi mínu á Íslandi. Á ferðum mínum seint á áttunda áratugnum og snemma á þeim níunda átti ég þar margar stundir, yljaði mér eftir kalda, óblíða veðráttuna. Er ég sneri aftur til að taka ljósmyndir af henni árið 1991 sagði húsvörðurinn mér að von væri á nýrri laug. Hann sagði mér einnig að þetta væri elsta innilaug á Íslandi, er ætti daga sína að telja aftur til upphafs þriðja áratugarins. Auk laugarinnar hýsti byggingin einstakan og fallegan heitan pott.* Annar fróðleiksmoli sem hraut af vörum húsvarðarins var sú staðreynd að fyrr á tímum var þessi bygging, sem sú stærsta í sveitinni, notuð sem eins konar samkomuhús; þegar fólkið úr nágrenninu kom saman eða fagnaði var laugin tæmd og hún notuð sem danssalur – fágað augnablik í sögu menningarheims þar sem allt veltur á útsjónarsemi.

*Sjá næsta hluta *Iceland's Difference (Sérkenni Íslands)*, Lesbók, 4. maí 2002.

Þetta er þriðji hluti í flokki sem í heild ber heitið: *Iceland's Difference (Sérkenni Íslands)*. © fyrir ljósmynd, 1991, og texta, 2002, Roni Horn.

LAUGAR, VESTFIRÐIR, 1991: This pool has a special place in my life in Iceland. When I was traveling in the late 1970s and early 1980s I spent a lot of time in it, warming up from the cold, inclement weather. I went back to photograph it in 1991. The caretaker told me that they were getting a new pool soon. He also pointed out that this was the oldest indoor pool in Iceland, dating back to the early twenties. The pool building housed a hot pot as well.* In earlier times the pool building, being one of the largest in the area, was used as a community center. When they had gatherings or celebrations they emptied the water out and used it as a dance hall—an exquisite moment in the history of a culture primed to improvisation.

(No. 3, *Iceland's Difference*, April 27, 2002)

* See next installment of *Iceland's Difference*, Lesbók, May 4, 2002

LAUGAR, VESTFIRÐIR, 1991: Frá upphafi þriðja áratugarins. Hér höfum við heita pott-
inn við danssalinn sem ég lýsti í síðustu grein þessa flokks.* Hann stendur fyrir notalegt
augnablik sem er engu öðru líkt í sögu íslenskrar byggingarlistar. Eins og sjá má býr pott-
urinn yfir sérstöðum þjóðrænum eiginleikum. En ég ætla einnig að lýsa honum, því svo ein-
stakir hlutir snerta mann og eru kveikjan að ógleymanlegri upplifun. Hugsið ykkur lítið
herbergi, svona þrisvar sinnum þrjá metra, með glugga og útsýni yfir grasi gróna hlíð. Ekk-
ert sérstakt útsýni í sjálfu sér en þegar vætan glæðir það líf – svo hagarnir renna saman í
skynrænt skýjað litaspil – umbreytist það í spegil hugans þar sem maður liggur þar í mak-
indum. Hugsið ykkur flísalagt gólf og yfir því kyrran spegil vatns. Maður fer að þessum
heita potti í gegnum upphækkaðar dyr á vegg sundlaugarinnar við hliðina. Og síðan stígur
maður niður, beint ofan í vatnið og inn í munúðarfullan og draumkenndan heim friðsældar.

*Sjá *Iceland's Difference (Sérkenni Íslands)*, Lesbók, 27. apríl 2002.

Þetta er fjórði hluti flokks sem í heild ber heitið: *Iceland's Difference (Sérkenni Íslands)*. © fyrir ljós-
mynd, 1991, og texta, 2002, Roni Horn.

LAUGAR, VESTFIRÐIR, 1991: Circa early 1920s. Here we have the hot pot to the dance hall I described in the last installment of the series.* It is a singular and intimate moment in the history of Icelandic architecture. Imagine a small room, perhaps two by three meters, with a window overlooking a grassy hillside. Not a particularly special view in itself but as enlivened by humidity, the fields are transformed into a sensuous palette of color, and become mirror to you as you loll here.

Imagine a tiled floor covered with still water. You enter this hot pot through a raised door in the wall of the adjacent swim room, and step down, directly into the water and into a luxuriant, other-worldly world of repose.

<div align="right">

(No. 4, *Iceland's Difference*, May 4, 2002)

</div>

* See No. 3, *Iceland's Difference*, Lesbók, April 27, 2002.

SUNDHÖLL, REYKJAVÍK, 1991: Hönnuð af Guðjóni Samúelssyni á árunum 1929–37. Hér erum við stödd við búningsklefana. Hefur þú einhvern tíma verið þar? Skoðaðu þessa ljósmynd gaumgæfilega. Tókstu eftir því að dyrnar eru bæði opnar og lokaðar í senn? Ef þú hefur komið í þessa sundlaug þekkirðu fyrirkomulagið sem á skylt við völundarhús og leikgleði skáklistar. Þegar ég aðgreini gluggana, gægjugötin, veggskotin, rýmin án skarpra brúna og dyr sem eru bæði opnar og lokaðar eða lokaðar og opnar finnst mér ég komast í snertingu við heimspeki.

Þetta er fimmti hluti flokks sem í heild ber heitið: *Iceland's Difference (Sérkenni Íslands)*. © fyrir ljósmynd, 1991, og texta, 2002, Roni Horn.

SUNDHÖLL, REYKJAVÍK, 1991: Designed by Guðjón Samúelsson in 1929–37. This is the locker room. Have you ever used it? Take a close look at this photograph. The door is *both* open and closed. If you've visited the swimming pool then you know its labyrinthine structure, its chess-like playfulness. When I factor in the mirrors, peepholes, niches, and spaces without edges, and the network of doors both open and closed, I feel near to philosophy.

<div align="right">(No. 5, Iceland's Difference, May 11, 2002)</div>

SUNDHÖLL, REYKJAVÍK, 2001: Hönnuð af Guðjóni Samúelssyni á árunum 1929–37. Við erum enn stödd í búningsherbergi.* Mitt í stærðfræðilegum skýrleika gólfskipulagsins birtist sérviskulegt smáatriði, kynlegt og forvitnilegt; gægjugötin sem gera hurðir klefanna svo torræðar. Hver klefi hefur sitt eigið útsýni. Og hvert útsýni sitt eigið rými. Hér er númer 124 og sena sem minnir mig á Vermeer. Eða eitt þessara málverka sem ber titilinn „Sá sem baðar sig".

*Sjá Nr. 5, Iceland's Difference, (Sérkenni Íslands), Lesbók, 11. maí 2002.

Þetta er sjötti hluti flokks sem í heild ber heitið: Iceland's Difference (Sérkenni Íslands). © fyrir ljós-mynd, 2001, og texta, 2002, Roni Horn.

SUNDHÖLL, REYKJAVÍK, 2001: We are still in the locker room.* Amidst the mathematical clarity of this floor plan—an idiosyncratic detail emerges, peculiar and intriguing: the *peepholes* that riddle the doors of the lockers. Each locker with its own view, and each view with its own private space. Here is number 124 and a scene that puts me in mind of Vermeer, or an impressionist painting of a bather.

(No. 6, *Iceland's Difference*, May 18, 2002)

* See No. 5, *Iceland's Difference*, Lesbók, May 11, 2002.

SUNDHÖLL, REYKJAVÍK, 2001: Ég er enn við búningsherbergi nr. 124,* og nota gægjugatið eins og sjónauka, súma að henni, jafnvel þó hún sé að ganga í burtu. Í burtu frá myndmáli „Þess sem baðar sig",* í burtu frá mér, og nú, í burtu frá þér – mýkist er hún fer, leysist upp og rennur saman við fjarlægan hvítleika flísanna. Frá öræðri, flókinni tilvist sinni að óhjákvæmilegri rökvísi röðunetsins, færist hún í burtu. Brátt verður hún alveg horfin. Rýmið sem hún skilur eftir sig, tóm þess og gljáfangsbur hreinleiki, gefur minningu um viðveru hennar ekkert færi. Í New York værum við „Peeping Toms" en erum við „Gægju-Pórar" hér í Reykjavík?

*Sjá síðasta hluta *Iceland's Difference (Sérkenna Íslands)*, 18. maí 2001

Þetta er sjöundi hluti flokks sem í heild ber heitið: *Iceland's Difference (Sérkenni Íslands)*. © fyrir ljósmynd, 2001, og fyrir hönnun og texta, 2002, Roni Horn. Fríða Björk Ingvarsdóttir þýddi.

SUNDHÖLL, REYKJAVÍK, 2001: I'm still at locker No. 124,* using the peephole as scope—zooming in closer, even though she's walking away. Away from the image of the bather, away from me, and now, away from you—softening as she goes, diffusing and melding into the distant whiteness of the tiles. From the indecipherable complexity of her presence to the inescapable logic of the grid, she is moving away. Soon she will be gone altogether. The space she leaves behind, its vacancy and hygienic purity, allows no memory of her presence.

<div align="right">(No. 7, Iceland's Difference, May 25, 2002)</div>

* See No. 6, *Iceland's Difference*, Lesbók, May 18, 2002.

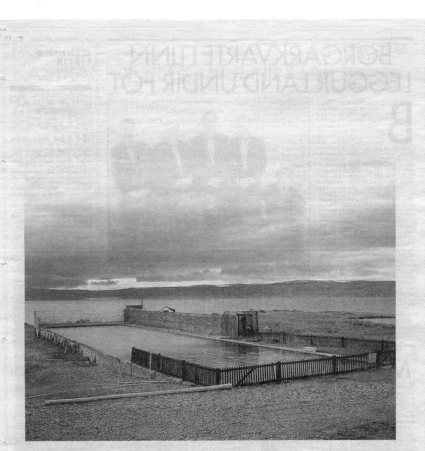

SUNDHÖLL, REYKJANES, ÍSAFJÖRÐUR, 1997: Ég veit ekki mikið um þessa sundlaug annað en það að hún er staðsett á einum efsta odda Íslands. Maður keyrir eftir vegi meðfram stórkostlega löguðum klettum, veðursorfnum í líki hvala* og annarra eftirmynda. Við enda línunnar, efst á landinu er sundlaugin, skammt suður af nálægum en ósýnilegum heimskautsbaugnum. Svo hér er ég. Og nú horfi ég á þessa mynd og hugsa um Timbúktú. Fyrir tveimur árum las ég grein í dagblaði um að Hvergi heimsins væri að fjúka í burtu. Um að flestir íbúanna hefðu farið og að þeir fáu sem urðu eftir eyddu tíma sínum í að sópa sandinum af dyraþrepunum hjá sér. Það leiðir að spurningunni: „Er hvergi horfið?"

* Sjá hluta næstu viku.

Þetta er áttundi hluti flokks sem í heild ber heitið: *Iceland's Difference (Sérkenni Íslands).* © fyrir ljósmynd, 2002, blæmun og texta, 2002, Roni Horn. Fríða Björk Ingvarsdóttir þýddi.

SUNDHÖLL, REYKJANES, ÍSAFJÖRÐUR, 1997: I don't know much about this pool except that it's at one of the tips of Iceland. You drive along a road edged with fabulously shaped rocks, eroded into whales* and various other likenesses. At the end of the line and the tip of the land sits this swimming pool, not too far south from the present but invisible Arctic Circle. So here I am. And now I'm looking at this picture and I'm thinking about Timbuktu. A couple of years ago I read an article in the newspaper about how *the* Nowhere of the world was blowing away. About how most of the inhabitants had left and the few that remained spent their time sweeping the sand from their doorsteps. This presents the question: "Is nowhere gone?"

(No. 8, *Iceland's Difference*, June 1, 2002)

* See next edition of *Iceland's Difference*, Lesbók, due out June 8, 2002.

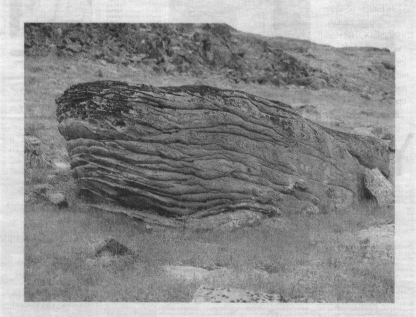

STRANDADUR HVALUR Í LÍKI KLETTS*- Á LEIDINNI AD HUGSANLEGU HVERGI REYKJANES, ÍSAFJÖRDUR, 1988:** Er hvergi horfið? Við nálgun á þessu viðfangsefni kem ég að spurningunni „Hvað er hvergi?" Orðabókin skilgreinir það sem „afskekktan eða óþekktan stað". Þvílík gæfa í slíkum fundi. Samkvæmt þessari skilgreiningu er Ísland sá staður sem hefur fleiri hvergi miðað við höfðatölu en nokkurt annað land. Jafnvel þó Timb-úktú sé feykt út í buskann, þá getur Ísland, þar sem jarðfræði þess er töluvert varanlegri, tekið forystuna sem helsti birgir heimsins hvað hvergi varðar. En burtséð frá því hversu hvergi er algengt á Íslandi, þá er hvergi auðlind sem ekki er hægt að endurnýja, sér-staklega viðkvæm fyrir ofnýtingu og óviðeigandi notkun. Ef því er breytt eða það er notað með röngum hætti þá hverfur þetta hvergi. Í mínum huga og jafnvel í skilgreiningum, þá felst í hvergi ein sjaldgæfasta, viðkvæmasta og unaðslegasta reynsla sem hægt er að hugsa sér. Að vera hvergi. Getur þú sagt að þú hafir reynslu af því?

*Strandaður klettur í líki hvals?
**Sjá hluta síðustu viku.

Þetta er níundi hluti flokks sem í heild ber heitið: *Iceland's Difference (Sérkenni Íslands)*. © fyrir ljós-mynd, 2002, bönnun og texta, 2002, Roni Horn. Fríða Björk Ingvarsdóttir þýddi.

BEACHED WHALE IN THE FORM OF ROCK*—ON THE ROAD TO A POSSIBLE NOWHERE, REYKJANES, ÍSAFJÖRÐUR, 1988:[†] Is Nowhere gone? In approaching this subject I come upon the question "What is nowhere?" The dictionary defines it as "a remote or unknown place." What a lucky find. By this definition Iceland is the place with more nowheres per capita than any other country. Even if Timbuktu is blown into oblivion, Iceland, by virtue of its more resistant geology, can become a leading supplier of nowhere to the world. But regardless of the apparent plenitude of nowheres in Iceland, nowhere is a non-renewable resource, deeply vulnerable to overuse and inappropriate occupation. Wrongly altered, wrongly used, that nowhere is gone. To my mind and even by definition, nowhere is one of the rarest, most fragile, and most delectable of experiences. To be nowhere. Can you say you have achieved this experience?

(No. 9, *Iceland's Difference*, June 8, 2002)

* Beached rock in the form of whale?
† See No. 8, *Iceland's Difference*, Lesbók, June 1, 2002.

ER ÞETTA HVERGI?- MELRAKKASLÉTTA, 1992: Kannski, en þetta Hvergi hefur rýrn-
að og færist í áttina að skilgreiningunni á einhversstaðar fyrir tilstilli leifa af því sem dembt
er í sjóinn. (Sést ekki á þessari mynd.) Á þessum stað flæðir ruslið upp á ströndina og safn-
ast saman í því hlutfalli sem staðhættir leyfa, en án þess að hafa margbreytileika og sáttfýsi
staðháttanna til að bera. Þrátt fyrir það finnur maður fyrir hinni stórkostlegu auðlegð Mel-
rakkasléttu. Hún birtist manni í nærandi, margslungnu sjónrænu og efnislegu tómi. Tómi
sem virðist flatt, opið, tært og óendanlegt. Af þessum hátíum er hér gnótt en tilvist þeirra
veltur á gnægðinni og hreinleikanum. Til viðbótar við þennan ríkuleika hvíla einkenni
heimsenda yfir Melrakkasléttu, hæði efnislega og sálrænt. Andrúmloftið er þrungið þögulli
eftirvæntingu. Ef til vill vegna hafsins, sem aðeins einum eða tveimur þumlungum neðar
býr yfir hótun um enn meira ríkjandi viðveru. Eða kannski er það tilfinning fyrir eitrinu,
óljós sem hún er, sem truflar tilfinninguna fyrir staðnum; eituráhrif sem verða til er hið
upphafna blandast við áberandi hlutföll polypropylens, polyethylens og annarra efnisþátta
grískra goðsagna.

Þetta er tíundi hluti flokks sem í heild ber heitið: *Iceland's Difference (Sérkenni Íslands).* © fyrir ljós-
mynd, 2002, hönnun og texta, 2002, Roni Horn. Fríða Björk Ingvarsdóttir þýddi.

IS THIS NOWHERE?—MELRAKKASLÉTTA, 1992: Perhaps, but this nowhere is diminished by the somewhere-defining residue of ocean dumping. (Not shown in this picture.) Here rubbish washes up on the shore accumulating in the scale of geology, but lacking its complexity and forgiveness.

Even so you experience the great wealth of Melrakkaslétta. It comes in the form of a fulfilling visual and physical emptiness, an emptiness experienced as flat, open, clear, and endless. These are things that are here in abundance and depend for their existence on amplitude and purity. In complement to this richness, an end-of-the-world quality pervades Melrakkaslétta, both physically and psychologically. A feeling of expectation silently dominates the atmosphere. Perhaps it is the ocean, only a few inches below, threatening a yet more dominant presence. Or maybe it's a sense of the toxic, ambiguous though it is, that disturbs the feeling of this place—the toxicity or intoxication that comes from a blending of the sublime with prominent portions of polypropylene, polyethylene, and other ingredients of Greek mythology.

(No. 10, *Iceland's Difference*, June 15, 2002)

ER ÞETTA EKKERT? – HVAÐA HNÚSKAR OG HNÚÐAR ERU ÞETTA? Hér höfum við völl hnúska og knubba í réttum hlutföllum við sjóndeildarhringinn. Hnúða og hnotta á afskekktum og óþekkjanlegum stað. Mosavaxnir hólar, hver og einn umlukinn mosavöxnum dal á breidd við fótinn á manni. Þessir dalir mynda vef og völundarhús. Þeir rugla mann ekki, en þeir hæggja á manni. Þeir ráða ferðinni, gefa ferðalagi manns hrynjandi. Þeir krefjast eins konar rándar, annars konar athygli sem fer saman við ógnvænleg hlutföll þessa víða, víða valbar. Því mann langar til að ganga, til að fara út á meðal þessara nautnalegu hnúða. Mann langar til að liggja á þeim og finna líkama sinn sem miðju þess sem er óendanlega opið og umsvifalaust náið. Maður verður að skurðpunkti, þeim stað þar sem þetta ekkert er að lokum nefnt.

*Melrakkaslétta, 1994.

Þetta er ellefti flokks sem í heild ber heitið: *Iceland's Difference (Sérkenni Íslands).* © fyrir ljós-mynd, 2002, hönnun og texta, 2002, Roni Horn. Fríða Björk Ingvarsdóttir þýddi.

IS THIS NOTHING?—WHAT ARE THESE HUMPS AND LUMPS?* Here we have a field of humps and bumps in the scale of the horizon. Lumps and rumps in a remote and unknowable place. Mossy mounds, each surrounded by mossy valleys the width of your foot. These valleys form a network and maze. They do not confuse but they slow you down. They pace you, give your travel cadence, move you along in a way particular to this place. They demand a kind of intimacy, another attention in complement to the awesome scale of this open, open space. Because you want to walk, to go out among these sensuous lumps. You want to lie upon them feeling your body a center point to the endlessly open and the immediately intimate. You become the intersection, the place where this nothing is finally named.

<div align="right">(No. 11, Iceland's Difference, June 22, 2002)</div>

* Melrakkaslétta, 1994.

MARGÞÆTT STARFSEMI
SVEINSSAFNS

*

***ER ÞETTA EKKERT?, MORGUNBLADID, 29. JÚNÍ, 2002, REYKJAVÍK:** Það væri til dæmis hægt að segja að á þessari blaðsíðu sé ekkert. En á meðan þú lest þennan texta ertu væntanlega að athuga pappírinn sem fréttirnar eru prentaðar á. Tekur eftir efnislegum eiginleikum þessa dagblaðs: mjúkum og trefjaríkum eiginleikum þess, ekki-alveg-ógagnsæjum þéttleikanum, muskuhvítum litnum og yrjóttri áferðinni. Þú virðir líklega fyrir þér ójafnt yfirborð síðunnar, sem ýfist aðeins í rakanum. Þú horfir á flekki af síðu fimmtán, sem sést í gegn hér og þar. Og ef þú gáir vandlega eru hlutar af íþróttafréttunum á næstu síðu sýnilegir líka. Þú horfir á pappírinn milda ljósið sem fellur á hann, finnur hann stilla hávaðann af lífinu í kringum þig og fanga athygli þína. Þú hlustar á skrjáfandi eiginleika hans þegar þú fitlar við pappírinn til að fá betra tak á honum, eða kannski til að sjá betur. En jafnvel í nálægð er tómleiki þessarar síðu, staðsett eins og hún er í lokin, full náttúru.

Þetta er tólfti hluti flokks sem í heild ber heitið: *Iceland's Difference (Sérkenni Íslands).* © fyrir ljósmynd, 2002, hönnun og texta, 2002, Roni Horn. Fríða Björk Ingvarsdóttir þýddi.

* IS THIS NOTHING?—*MORGUNBLAÐIÐ*, JUNE 29, 2002, REYKJAVÍK:

You may say of this page, for example, that there is nothing here. But as you read this text you are likely checking out the paper on which the news is printed. Noticing the physical stuff of the newspaper: its soft and fibrous quality, the not-quite-opaque density, the dirty-white color, and the mottled texture. You are probably observing the uneven surface of the sheet, lightly warped in the humidity. You are seeing patches of page fifteen, showing through here and there. And if you look carefully, bits and pieces from the sports news on the previous page are visible as well. You are seeing the paper tempering the light that falls on it, feeling it quiet the noise of peripheral activity and focus your attention. You are listening to its noisy character as you rustle the paper trying to get a better grasp, perhaps trying to get a closer look. But even close up the emptiness of this page, poised as it is at the end, is full of nature.

(No. 12, *Iceland's Difference*, June 29, 2002)

ÞAÐ VAR EINS OG EKKERT: En hvernig það gerðist, hvernig það einfaldlega gerðist, eins og allt annað gerist, nema það skipti máli. Það var eins og ekkert og það var eins og hending. Ég var niðri við höfnina í Reykjavík. Lok dagsins nálguðust. Sólin var andartök handan við sjóndeildarhringinn, en loftið mettað ljósi. Ljósið var af því tagi sem hefur enga augljósa uppsprettu. Ljós sem virtist vera lífrænn þáttur hvers hlutar. Það féll jafnt og með sama styrk á allt. Með fáguðum skýrleika dró það fram hvern einasta hluta útsýnisins. Ég var bergnumin yfir hverjum fleti, burt séð frá stærð, lögun eða virði. Augnatillit mitt hafði sömu almánd og ljósið. Og í þeirri nýju vitneskju fann ég sjálfa mig magnast, skýrast, auk þess að vera dregin fram.

Þegar tíminn leið bar hann með sér dimmu sem var sýnileg og síðan dimmu sem var of dimm til að sjást. Þau umskipti, í raun svo óljós – svo óljós að þau leysast án ummerkja upp í ósýnilegan en skynjanlegan hápunkt. Og næstum án vitundar um það skildist mér að ég var að horfa á hlut breytast með réttækum hætti fyrir augum mér án þess í raun að sjá breytingarnar. Með þeim hætti verður útsýni hluti af manni sjálfum.*

* Hvaða mynd setti að hafa hér? – Óvenjulegum veruleikum er ekki hægt að halda aðgreindum frá reynslu manns af þeim án þess að eyðileggja þá.**

**Wallace Stevens, hérumbil.

Þetta er þrettándi hluti flokks sem í heild ber heitið: *Iceland's Difference (Sérkenni Íslands).* © fyrir hönnun og texta, 2002, Roni Horn. Friða Björk Ingvarsdóttir þýddi.

IT WAS LIKE NOTHING: Just like nothing. But the way it happened, the way it *just* happened, like everything else happens, but with a difference. It was like nothing but it was like an accident too.

I was down by the harbor in Reykjavík. The end of the day was approaching. The sun was moments beyond the horizon, but the air was filled with light. It was a light with no apparent source, a light that seemed to be an organic part of each thing. It cast itself with equal intensity everywhere. With exquisite clarity it named each part of the view. Every aspect, no matter its size or shape transfixed me. My gaze was ubiquitous as the light. And in this new knowledge I felt myself intensified, clarified, and named too.

Time passing brought a darkness that was visible, and then a darkness too dark to see. That shift, so delicate and nuanced, that shift diffusing seamlessly into an invisible but sensible climax. And almost without knowing, I understood that I was watching a thing change radically before my eyes without actually seeing the change. In this way a view becomes a part of you.

(No. 13, *Iceland's Difference*, August 24, 2002)

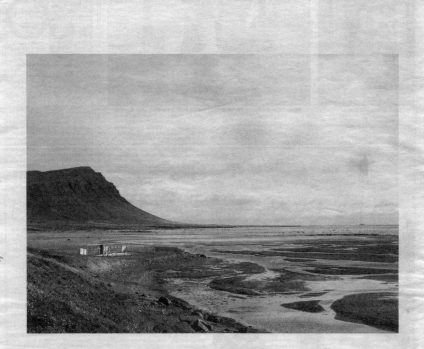

HJÖRTU HVERGISINS: Í næstu köflum langar mig til að staldra við hin mörgu hjörtu hvergisins sem dreifð eru um Ísland.* Það mun marka upphaf; verða lítil samantekt á þessum óvenjulegu og nauðsynlegu stöðum.

Útilaugar og heitir pottar gefa hvergjum eyjunnar einstakt aðdráttarafl vegna tengsla sinna við heitt vatn. Ef til vill er það ekki einungis nálægð þeirra við uppsprettu hita sem greinir reynsluna af þeim svo rækilega frá allri annarri, heldur sú staðreynd að sá hiti er ekki af því tagi að manni falli allur ketill í eld. (Hann er samt ekki tengdur skjóli eða öðrum þægindum eða aðstöðu sem náttúran hefur upp á að bjóða.) Þess vegna er stund í heitum pottum og ákveðnum laugum sem maður rekst á líklegt til að vera laus við hinu stórbrotna og því sem er síður aðgengilegt. Hún er einnig líkleg til að vera þrungin hinu stórbrotna og því sem er síður aðgengilegt.

Veigamikill þáttur nautnarinnar, athafnarinnar og umbúnaðar þessara smáu en upprunalegu gleðigjafa felst í því að hreiðra um sig í landslagi fjarlægra staða. Þar gefst möguleiki á nánni upplifun, eða jafnvel einveru úti á víðavangi. Náinni upplifun og einveru sem ekki hefur orðið til fyrir tilstilli stefnumótunar eða félagslegra tengsla, heldur vegna óvenjulegs samruna hins afskekkta, nánast ósnortins náttúrulegs umhverfis og þeirrar athafnar að vera í heitu vatni úti undir beru lofti, og á almannafæri. Það er þessi staðreynd sem gefur þeim einstaka eiginleika og gerir þau tilefni sem þeir bjóða upp á svo fáguð.

Reynslan af ylnum í þessum laugum og pottum veltur að miklu leyti á hitastig-

inu sem umlykur mann, en það er undirstaða spaklegs samleiks við staðinn. Því ert nákvæmlega á þeim stað sem þú ert á og hvergi annars staðar; líkamshiti þinn, hiti vatnsins og loftsins rennur einmitt saman í þér, fyrir tilstilli munúðar og hrífandi skynjunar á mismun. Hér er því leið til að leggja hvergið undir sig án þess að breyta eigindum þess. Og það er lykillinn – að vera hvergi, að koma aftur til hvergisins, að staldra við og jafnvel þrá hvergið, en leyfa hverginu að vera það sjálft.**

* Á myndinni að ofan sést Mórudalur, Barðaströnd, Vestfjörðum, 1991.

** „Itself is all the like it has –" (Það sjálft er það eina sem líkist því) úr ljóði nr. 826 frá 1864, eftir Emily Dickinson.

Þetta er fjórtándi hluti flokks sem í heild ber heitið: *Iceland's Difference* (Sérkenni Íslands). © fyrir ljósmynd, 1991, fyrir hönnun og texta, 2002, Roni Horn. Fríða Björk Ingvarsdóttir þýddi.

LITTLE HEARTS OF NOWHERE: I want to spend time in the next few editions on some of the many hearts of nowhere scattered throughout Iceland.* It will be a beginning, a small sampling of these unusual and necessary places.

Keyed to the presence of hot water, outdoor pools and hot pots bring unique appeal to the nowheres of the island. Setting the experience of them profoundly apart from any other is not so much their nearness to sources of heat but the fact that this heat is not associated with any kitchen, harbor, or other opportunity of comfort or facility present in nature. And so an encounter with a hot pot and a select number of pools is likely to be free of neighbors and human activity generally. It is also likely to be full of the majestic.

A big part of the enjoyment, ritual, and form of these little but elemental delights is in being nested in the landscape in faraway places. It is the possibility of intimacy, even privacy in a vast public domain. An intimacy and privacy created not by politics or social relations but by the unusual conjoining of remoteness, undisturbed natural settings, and the act of being in hot water in the open, *and in public*. It is these facts that give them their unique identity and make the occasions they offer so unique.

The experience of warmth in these pools and pots is deeply dependent on ambient temperature, establishing the basis of a profound exchange with place. You are in the very spot you are in and nowhere else; your body temperature, that of the water, and that of the air are all linked precisely in you through the sensual and delicious perception of difference. So here is a way to occupy nowhere without changing its identity. And this is the key—to be nowhere, to revisit nowhere, to linger in nowhere, but to allow nowhere to remain itself.[†]

(No. 14, *Iceland's Difference*, August 31, 2002)

* Pictured is Mórudalur, Barðarströnd, West Fjords, 1991.

† "Itself is all the like it has—" from Emily Dickinson, poem no. 826, 1864. Emily Dickinson, "Love reckons by itself—alone" ca. 1864, in *The Poems of Emily Dickinson*, vol. II, ed. Thomas H. Johnson (Cambridge, MA: Belknap Press of the Harvard University Press, 1955), p. 626.

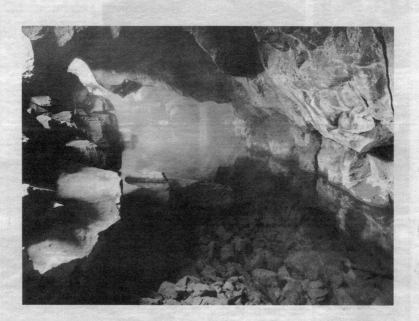

SAMRUNI VIÐ HVERGIÐ: Áður en gosið í Kröflu leiddi til þess að vatnið varð of heitt til að sitja í því, var Grjótagjá innra rými í tvöföldum skilningi: greypt inn í skorpu jarðarinnar svo maður þarf að fara inn í gjána í gegnum op í klettunum, og svo þaðan ofan í frið og ró hlýs uppsprettuvatnsins, sem nú er mjög heitt. Í hellinum magnar magnar skjólið frá vindinum kyrrðina; endurómunin þéttir og eflir hljóð. Dagsljósið sem stast inn í hellinn tvístrast um blautt grjótið, slær birtu á gufumettað loftið og lýsir rýmið á hverflyndan og síbreytilegan máta. Og kemur manni í náin tengsl við veðrið. Í þessari kyrru umgjörð úr grjóti gefur stilla vatnsins og fullkominn tærleiki heimi sem er fullkomlega sýnilegur færi. Stað sem býr yfir heilindum og skyggni er tvöfaldast í þeim spegli er laugin myndar.

Grjótrýmið er af því umfangi að ekkert er langt í burtu og utan seilingar og ekkert of nálægt og utan seilingar – það greiðir fyrir órofnu flæði á milli manns sjálfs og alls þess sem er umhverfis. Ég minnist dagrenningar árið 1975 – fyrstu kynna mína af Grjótagjá. Þar sem ég sat í vatninu fann ég hvernig ég byggðist upp, hvíldist hægt og hresstist, varð hluti af þessari kyrrð, varð hluti af þessum stað.

Þetta er fimmtándi hluti flokks sem í heild ber heitið: *Iceland's Difference* (Sérkenni Íslands). © fyrir ljósmynd, 1991, fyrir hönnun og texta, 2002, Roni Horn. Fríða Björk Ingvarsdóttir þýddi.

BECOMING A PART OF NOWHERE: Before the eruption of Krafla made the water too hot to sit in, Grjótagjá was a double interior. Tucked into a crack in the crust of the earth, you enter Grjótagjá through an opening in the rocks, and from there into the ease and quiet of the warm, now very hot spring-fed water. In the cave, shelter from the wind intensifies stillness; resonance thickens and amplifies sound. Into the cave daylight filters scattering among the rocks, brightening the steamy air, and illuminating the space in a moody, changeable manner, placing you in keen relation to the weather. In this still rock surround the water's still and perfect clarity allows a world that is wholly visible. A place whose wholeness and visibility is doubled in the mirror the pool forms.

The rock interior is of a size where nothing is faraway and inaccessible and nothing is too close and inaccessible—facilitating an uninterrupted flow of relation between you and everything around you. I remember an early morning in 1975—my first experience of Grjótagjá. Sitting in the water I felt myself being composed, slowly eased and fitted, becoming a part of that stillness, becoming a piece of that place.

(No. 15, *Iceland's Difference*, September 7, 2002)

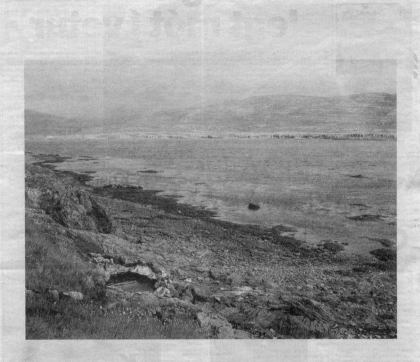

HVERGI, EN MEÐ LOFTBÓLUM: Úti á meðal allra þeirra auðgandi og mestmegnis tómu hvergja* sem fyrirfinnast á Íslandi, eru heitu laugarnar. Laugarnar verða til þess að staðar er ljáð ending, svo maður gefur honum þann gaum er leyfir hvergjum að þrífast. Þar sem maður situr í þessari tilteknu laug í Vatnafirði (sem hér sést á fjöru) er maður staddur á stað sem er á stöðugri hreyfingu með hafinu og einbeittum vindinum. Hér hef ég upplifað sjálfa mig eins og ég væri á miðpunkti, kannski ekki heimsins, heldur staðar sem er í senn afmarkaður og í jafnvægi, opinn og umlykjandi. Kitlandi, mjúk áhrif koltví- sýringsmettaðs vatnsins leiða til þess að sýn manns á himininn, hafið og veðrið virðist ótakmörkuð; blástur hiti vatnsins og kaldur hvítur vindsins renna saman í líkama mín- um. Að nótu til er sndáningur jarðar; markaður með breytingum stjörnumerkjanna, sú hreyfing sem er auðveldast að koma auga á. Að degi til er það blástur vindsins yfir víð- áttu hafsins, í gegnum loftið, um vallendið og meðal villtra blómanna, sem gerir alla hluti í kringum mig sjáanlega með öllikum hætti.

*Sjá t.d. 10. og 11. hluta *Iceland's Difference* (Sérkenna Íslands), Lesbók, 15. og 22. júní 2002.

Þetta er sextándi hluti flokks sem í heild ber heitið: *Iceland's Difference* (Sérkenni Íslands). © fyrir ljósmynd, 1991, fyrir hönnun og texta, 2002, Roni Horn. Fríða Björk Ingvarsdóttir þýddi.

A NOWHERE WITH BUBBLES: Out among all the enriching and mostly empty nowheres* of Iceland are the hot pots. Hot pots in a sense, give duration to a place, encouraging attention, allowing nowheres to flourish. Sitting in this particular pot in Vatnsfjörður (pictured here at low tide) you find yourself in a place of constant motion among the ocean waters and the concentrated winds. Here I've found myself as though in a center, maybe not of the world, but of a place balanced and bounded, open and inclusive. Along with the tingling and tender sensation of carbonated water, the view of sky, ocean, and weather is seemingly endless; the wet heat of the water and cold snap of the air fuse in my body. At night, the rotation of the earth, ticked off in changing constellations is the most visible activity. In the day the blow of the wind across the ocean expanse, through the air, and among the ground cover and wildflowers, makes all things around me visible differently.

(No. 16, *Iceland's Difference*, September 14, 2002)

* See, for example, Nos. 10 and 11, *Iceland's Difference*, Lesbók, June 15 and 22, 2002.

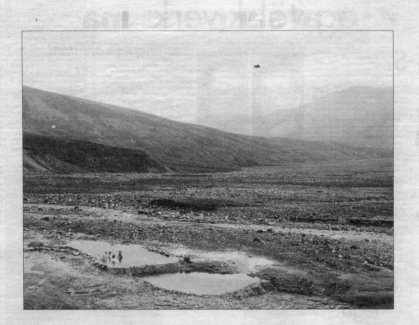

Í ÖDRU HVERGI–*PROMISE TO LOVE YOU FOR EVERMORE* (loforð um að elska þig að eilífu): Fyrir tíu árum sílaðist ég þungann úr degi áfram á bíl um það bil tuttugu kílómetra leið í veglausu landslagi á afvíknum stað er leynist handan við Mýrdalsjökul. Að lokum kom ég að stóru svæði þöktu grjóturð, í dal umkringdum hæðóttu landslagi. Yst, hinum megin á svæðinu, var heiti potturinn Strútur og einnig áfangastaður minn. Það var nánast ómögulegt að koma auga á hann, nema vegna þess að áferð urðarinnar sem myndar umgjörð hans var þar með öðrum hætti og vegna gróðursins sem óx hikandi í kring. Stærri steinar, nánast hnullungar, mynduðu grófa línu er myndaði tvær hliðar pottsins. Vatninu hafði verið veitt frá sínum náttúrulega farvegi með fáeinum steinum sem hnikað hafði verið frá sinni jarðfræðilegu öreið í átt að einhverju sem tilheyrði þó ekki alveg rúmfræði. Innan marka þessarar endurskipulögðu grjóturðar safnaðist vatnið saman, og flæddi að hluta yfir svæðið umhverfis.

Þannig er sem sagt heiti potturinn, eða í það minnsta hinn áþreifanlegi þáttur hans. En áður en ég komst alla leið þangað, hafði þokuslæðingur lagst yfir svæðið. Í fjarska sá ég skæriíta, flúrljómandi flekka hreyfast taktfast á stað þar sem kortið mitt gaf til kynna að Strútur væri staðsettur. Samstilltir flekkirnir virtust skoppa og bylgj-ast, eins og hópur dansara í sjálfýsandi ballettverki. Þessi dansandi bjarmi var það eina sem var sýnilegt í gegnum þokuna er huldi allt annað í sjónmáli. Stutt einangruð augnablik vék vélarhljóðið í þögninni fyrir daufum röddum, sem voru nánast eins og tónlist. Þær hljómuðu kunnuglega en óljóst í fyrstu, hljóðið var of dempað. Á meðan ég mjakaðist áfram yfir urðina, hætti það að vera slitrótt og raddirnar urðu að tónlist. Hún virtist dreifast um loftið án þess að eiga sér ákveðin upptök. Óþekkjanleg í fyrstu, ómælhýjanleg að lokum. „...Waterloo – I was defeated, you won the war. Waterloo – Promise to love you for evermore. Waterloo – Couldn't escape if I wanted to. Waterloo...“* ómaði í áttina til mín. Og fyllti loftið nokkurn veginn með sama hætti og þokan – ræðilega og með sívaxandi þunga.

*Úr „Waterloo“ eftir B. Anderson og B. Ulvaeus. © 1974, Union Songs AB.

Þetta er sautjándi hluti flokks sem í heild ber heitið: *Iceland's Difference (Sérkenni Íslands).* © fyrir ljósmynd, 1991, fyrir hönnun og texta, 2002, Roni Horn. Fríða Björk Ingvarsdóttir þýddi.

IN ANOTHER NOWHERE—*A PROMISE TO LOVE YOU FOREVER-MORE:* Ten years ago I spent a day, nearly all of it, working my way by car through something like twenty kilometers of roadless landscape neatly tucked away behind Mýrdalsjökull. Eventually I arrived in a large, scree-covered clearing, a valley bounded by mountainous terrain. On the far side of the clearing was the hot pot, Strútur, also my destination. It was virtually invisible except for the differently arranged rubble that composed its structure and the greenery that was growing tentatively around it. Larger rocks, almost boulders, were set in a rough line that formed two sides of the pot. The hot water was diverted from its natural flow with a few stones moved slightly from their geologic disarray toward something not quite geometry. Inside this rock re-arrangement water gathered, partially flooding over into the surrounding field.

So that's the hot pot, at least the physical part of it. But before I actually arrived there, a light fog had settled over the clearing. In the distance I could see brightly colored fluorescent patches moving rhythmically in the place where my map indicated the location of Strútur. The patches appeared to bounce and wave in unison. This undulating glow was the only thing visible through the mist that obscured the rest of the view. For brief isolated moments, the motór-silence gave way to faint voices, almost music. They felt vaguely familiar at first, but the sound was too muffled. As I continued slowly over the rubble, the intermittent quality disappeared and the voices gradually became song. It seemed to filter through the air from no place in particular. Unrecognizable at first, inescapable at last, "Waterloo" wafted toward me. "Waterloo, I was defeated, you won the war. Waterloo, promise to love you for ever more. Waterloo, couldn't escape if I wanted to. Waterloo . . . "*

(No. 17, *Iceland's Difference*, September 21, 2002)

* "Waterloo": Words and Music by Benny Andersson, Bjorn Ulvaeus and Stig Anderson. Copyright © 1974 UNIVERSAL/UNION SONGS MUSIKFORLAG AB. All Rights in the U.S. and Canada Administered by EMI GROVE PARK MUSIC INC. and UNIVERSAL-SONGS OF POLYGRAM INTERNATIONAL, INC. Exclusive Print Rights for EMI GROVE PARK MUSIC INC. Administered by ALFRED MUSIC. All Rights for UK/Eire Administered by BOCU MUSIC LTD. Used by Permission of Hal Leonard LLC and ALFRED MUSIC.

You are the dancing queen

Young and sweet

Only seventeen

Dancing queen

Feel the beat from the

tambourine

You can dance

You can jive

Having the time of your life

See that girl

Watch that scene

Dig in the dancing queen*

SUMARIÐ 1979 VAR MJÖG VOTVIÐRASAMT: Ég var stödd á Hellu til að kanna hellana rétt fyrir utan bæinn. Upprunalega voru þeir grafnir sem hluti af klaustri, en nú voru þeir notaðir sem kartöflugeymslur. Þessi neðanjarðarherbergi vöktu athygli mína vegna þess hve inngangarnir að þeim voru óvenjulegir. Að utanverðu var sjálf grasigróin hæðin. Í hana voru skorin moldarþrep sem lágu að trédyrum er opnuðust inn í jörðina. Sumir voru jafnvel einfaldari, ekkert nema hurð soðin beint í brekkuna. Umskiptin voru mikil, maður stóð ýmist úti í rigningunni eða í djúpu, svölu myrkri jarðarinnar, og jafnframt í takmarkalausu myrkri hnattarins.

Ég kom við á bensínstöðinni og ákvað að fá mér kaffibolla. Settist niður nálægt stórum glugga sem sneri að forugum vegi er skildi á milli mín og hæðanna með kartöflugeymslunum. Konan sem afgreiddi mig hvarf inn í bakherbergi. Þokan sem ráðið hafði ríkjum mestallan daginn vék fyrir rigningunni. Ég sat og hlustaði á regndropana lemja rúðuna með dauflegum dynkjum. Eftir stundarkorn kom gamall maður inn, hristi af sér bleytuna og bað þannig enda á nánast algjöra þögnina. Hann keypti sígarettupakka og kaffibolla og settist niður andspænis mér við næsta borð. Augu okkar mættust þegar hann var að veiða kveikjara upp úr skyrtuvasa sínum. Hann bauð mér að reykja og er ég afþakkaði hófust samræður okkar. Fyrst á veðrinu, síðan talaði hann um uppvöxt sinn á þessu svæði, en umræðuefnið tók óvænta stefnu að tónlist, þegar skyndilega var hækkað í útvarpi og dægurlag fyllti loftið. Hann lifnaði allur við er hann heyrði lagið og hóf að lof-

syngja dægurtónlist almennt – hann lýrjaði: „Í rauninni hafa aðeins verið til þrjár mikilvægar hljómsveitir. Það er að segja á seinni hluta aldarinnar. Sú fyrsta," benti hann á, „voru Bítlarnir." Hver gæti fært rök gegn því, hugsaði ég, jafnvel þó hann væri ekki aðdáandi þeirra. „Og þú persónulega," hélt hann áfram, „sé ég hrifnari af Bítlunum, þá finnst mér Rolling Stones líka mikilvæg." Ég hafði enga skoðun á þessu, á hvorn veginn sem var. Þá, um leið og hann kveikti í enn einni sígarettu í örofinni keðju, sagði hann, „en sú hljómsveit sem er þó augljóslega langmikilvægust," og hér skaut hann inn hugrenningum um hversu eðlislæg tónlist er Íslendingum og vísaði til langrar hefðar í kórsöng sem nýtur sérstakra vinsælda í sveitunum. „En," hann hvarf aftur til upprunalegu hugsunar sinnar, „langmikilvægasta hljómsveitin er," og hér hikaði hann, eins og til að leggja áherslu á vægi afstöðu sinnar, „Abba".

*Úr „Dancing Queen", © 1976 Polar Music International AB. Texti eftir B. Andersson, S. Anderson, B. Ulvaeus.

Þetta er stílandi hluti flokks sem í heild ber heitið: Iceland's Difference (Sérkenni Íslands). © fyrir hönnun og texta, 2002, Roni Horn. Fríða Björk Ingvarsdóttir þýddi.

IT WAS AN UNUSUALLY WET SUMMER IN 1979: I was down in Hella, exploring the caves just outside of town. Originally built as monasteries, they were now used as potato cellars. I was attracted to these subterranean rooms by way of their remarkable entrances. From outside there was the grass covered hill itself. Cut into it were earthen steps that led to a wooden door opening into the earth. Some were even simpler, just a door fitted directly into the hillside. There was no transition, either you were standing in the rain or you were in the deep cool darkness of earth. And deep in the unmeasured darkness of the earth, as well.

Stopping at a gas station nearby I sat down with a cup of coffee. A large window overlooked the muddy road separating the station from the potato cellars. What had been a thick fog for most of the day became heavy rain. I sat listening to the raindrops falling in dull thuds against the window. After a short while an old man entered, shaking off his wetness and extinguishing the near silence. He purchased a pack of cigarettes and a cup of coffee and sat down facing me at the next table. From his shirt pocket he was taking a lighter when our glances met. He offered me a smoke.

It started with the weather, and then he reminisced about growing up in the area. About what it was like to grow up in a tiny town not close to much of anything. But the subject changed suddenly when a radio in the back room was turned on and a pop song filled the air. Animated by the tune the old man launched into an appraisal of pop music in general: "Basically, there've only been three music groups of any importance. The first," he pointed out, "was the Beatles." Who could argue with that I thought, even if you're not a fan. "And though my personal preference is the Beatles, I think the Rolling Stones are important, too." And then, after lighting another cigarette, he continued. "But in Iceland the most important music group is," and here he went off on the importance of music in Icelandic culture, talking about the tradition of choir music especially popular in the countryside. "But," returning to his previous thought, "the most important group is," and here he paused to reinforce the gravity of his position, "the most important group is Abba."

(No. 18, *Iceland's Difference*, September 28, 2002)

"Dancing Queen": Words and Music by Benny Andersson, Bjorn Ulvaeus and Stig Anderson. Copyright © 1976, 1977 UNIVERSAL/UNION SONGS MUSIKFORLAG AB. Copyright © 1976 POLAR MUSIC AB (Sweden). All Rights in the U.S. and Canada Administered by UNIVERSAL-SONGS OF POLYGRAM INTERNATIONAL PUBLISHING, INC. and EMI GROVE PARK MUSIC, INC. Exclusive Print Rights for EMI GROVE PARK MUSIC INC. Administered by ALFRED MUSIC. All Rights for UK/Eire Administered by BOCU MUSIC LTD. Reprinted by Permission of Hal Leonard LLC and ALFRED MUSIC.

ÁIN VAR HORFIN.

Á ferðalagi um Heklusvæðið er erfitt að horfa framhjá því hversu landmyndun, sem búið er að umbylta af manna völdum, og eftirlíkingar af náttúru er ríkjandi þáttur í upplifun manns af svæðinu. Ýmislegt kemur upp í huganum: 1. Borið saman gömul og ný kort af Íslandi og áhrif Landsvirkjunar á landslagið, sem er eins og ævisneskur ostur, verða augljós. Ný vötn, sem hafa sprottið upp hér og þar, gata landslagið í auknum mæli. Brýnt er að kortleggja þau nýju kennileiti sem fyrst. Við það að ganga eða keyra fram á ókunn vötn á kortlögðu svæði stendur maður frammi fyrir nýrri og þversæðukenndri leið til að villast: Maður er ekki villtur vegna þess að manni sé ókunnugt um hvar maður er, heldur vegna þess að þar sem maður er, er ekki eins og það er. 2. Þörf er á nýjum vegvísum fyrir sum þau náttúrulegu undur Íslands sem nú eru breytt eða stopul. Og þar sem mörg mannvirki Landsvirkjunar eru ekkert annað en pípulagnir í jarðfræðilegum stærðarhlutföllum – þar sem eftirspurn eftir orku er látin stýra daglegu eða vikulegu flæði ár, foss eða hjálandi lækjar – gæti nýr vegvísir hljómar eitthvað á þessa leið:

...foss 7 km, einungis á mánudögum & þriðjudögum

3. Endurskoðuð upplýsingaskilti kæmu sér vel fyrir ferðamenn til að útskýra hin mörgu opinberu/stóriðju verkefni sem nýlega hafa verið framkvæmd á landsbyggðinni. Nýtt upplýsingaskilti gæti hljómað eitthvað á þessa leið, ef Þjórsá yrði tekin sem dæmi:

Þjórsá er stærsta og öflugasta jökulá á Íslandi. Nú til dags, þökk sé stuðningi ykkar og þeim grunnframkvæmdum sem *Orkustjórnin*™ hefur nýlokið við, er Þjórsá arðsamasta náttúruundur á Íslandi. Yfir ferðamannatímann og ykkur til enn frek-

ari ánægju mun Þjórsá flæða „au naturale" tvisvar í viku. Við mælum ekki með heimsóknum aðra daga þegar óeðlilega lítið vatnsmagn veldur vonbrigðum. Utan ferðamannatímans og þegar enginn er til staðar verður Þjórsá stýrt samkvæmt aðhaldssamari áætlun.

Við vekjum einnig athygli á því að þó sum þeirra skorninga, gilja og gljúfra sem Þjórsá rann eitt sinn í gegnum séu nú tæknilega séð úrelt höfum við ákveðið að varðveita náttúrulega eiginleika þessara landmynda svo hægt sé að njóta þeirra áfram. Það er í samræmi við þá skuldbindingu okkar, þegar því verður við komið, að endurheimta náttúrulegt, eða því sem næst náttúrulegt, útlit hins hagrædda umhverfis. Trú okkar er að það sem *lítur út* fyrir að vera eðlilegt sé eðlilegt. Og við hjá *Orkustjórninni*™ gerum allt sem í okkar valdi stendur til þess að halda óspjölluðu útliti náttúrunnar við.

Í nokkrum tilfellum höfum við sökkt svæðum með sjaldgæfum jarðfræðilegum fyrirbrigðum. Í framtíðinni hökkum við til að setja á stofn heimildasafn um þau fágætu fyrirbrigði sem útrýmt hefur verið. Þegar þeirri framkvæmd er lokið getum við með sönnu sagt að ekkert af hinum jarðfræðilegu undrum Íslands hafi glatast.

Við vonum að þið njótið þjóðvegakerfisins sem við höfum hannað til að auðvelda byggingu stíflnanna. Okkur er ánægja af því að bjóða almenningi ókeypis afnot af þessum vegum. Það er trú *Orkustjórnarinnar*™ að vegirnir muni eiga drjúgan þátt í því að almenningur meti meira hina óbeisluðu og einstöku arfleifð þjóðarinnar.

*Að ofan; koparstunga af Geysi, listamaður óþekktur.

Þetta er rit:jándi hluti fólks sem í heild ber heitið: *Ireland's Difference (Sérkenni Íslands).*© Fyrir höonun og texta, 2002, Roni Horn. Fríða Björk Ingvarsdóttir þýddi.

Shown above: engraving of Geysir, artist unknown.

THE RIVER WAS GONE. When traveling in the vicinity of Hekla it is hard to ignore how artificially altered geology and simulation nature dominate the experience of the area. A few observations come to mind: 1. Check the maps of Iceland past with present and the Swiss-cheese influence of Landsvirkjun on the landscape is plainly visible. New bodies of water sprout here and there perforating the landscape in increasing numbers. Timely mapping of these new landmarks is essential. The appearance of unidentified bodies of water when walking or driving in a mapped terrain introduces a novel and paradoxical way of being lost: You are lost not because you don't know where you are but because where you are is not what it is. 2. New road signs are needed for some of Iceland's revised and now intermittent natural wonders. Given that many of Landsvirkjun's structures are in fact a geologically scaled form of plumbing—allowing demand for power to dictate the daily or weekly flow of a river, a waterfall, a babbling brook, a new road sign might read:

[e.g. GULL] FOSS 7 KM, MONDAYS & TUESDAYS ONLY

3. Updated information panels will be useful for travelers to explain the many civil/industrial projects recently constructed in the countryside. Using Þjórsá as an example, a new panel might read:

> ÞJÓRSÁ IS THE LARGEST and mightiest glacial river in Iceland. Today, thanks to your support and the infrastructure recently completed by *THE POWER AUTHORITY*™ Þjórsá has become the most profitable natural wonder in Iceland. During the tourist season, and for your pleasure Þjórsá will be running "o' naturale" twice a week. However we recommend that you do not visit on off days as the artificially low level of the river will disappoint. Off-season and in your absence Þjórsá will be kept to a more modest schedule.

> We note as well that while some of the gorges, ravines, and canyons Þjórsá once ran through are now technically obsolete, we have chosen to maintain the organic integrity of these formations for your continued enjoyment. This conforms with our commitment when possible to restoring the natural or nearly natural appearance of the manipulated environment. We believe that when something looks natural it is natural. And we at *THE POWER AUTHORITY*™ are doing everything possible to keep the look of nature intact.

In some instances we have flooded areas of rare geologic occurrence. In the future we look forward to opening a museum documenting these extirpated former rarities. And with this achievement we can truly say that nothing of the geologic wonder of Iceland will be lost.

We hope you will enjoy the highway infrastructure we have created to facilitate the building of our dams. We are pleased to offer the public use of these roads free of charge. *THE POWER AUTHORITY*™ believes these roads will contribute greatly to the public's appreciation of the nation's wild and unique birthright.

<div align="right">(No. 19, Iceland's Difference, October 5, 2002)</div>

HALLÓ KISULÓRA. Ég var við vinnu í skóla í Reykjavík í nokkra daga þegar ég fann þennan kettling. Það var veturinn 1998. Feldurinn á honum bjó yfir óvenjulegri mýkt, líkt og lambseyra. Vegna þess hve hann var einkennilega varnarlaus, virtist hann jafnvel enn mýkri. Skólabörnin sem struku honum voru sama sinnis, svo þau lögðu vanga sína só maganum á honum til þess að finna nákvæmlega hversu mjúkur. Ég setti hann niður á blátt línóleumgólfið og tók þessa mynd.

Á þeim tíma sem ég fann hann var að ljósmynda öll þau dýr sem eru Íslandi upprunaleg og hinn hversdagslegi húsköttur er ekki eitt þeirra. En ég stóðst ekki freistinguna. Kisa er á veiðum. Og jafnvel þótt frumskógurinn sé bara línóleumdúkur er rándýrsstellingin raunveruleg. Og þótt hún ágiát einungis aftan frá, eru eiginleikar forvitni og óskammfeilni, jafnvel ærsla þekkjanlegir. Þótt augnatilliti hennar sé hulið finnum við greinilega fyrir því. Og þótt við sjáum ekki á hvað hún horfir, vitum við að það er til staðar."

*Sjá næsta hluta Iceland's Difference (Sérkenni Íslands), Lesbók , 19. október, 2002.

Þetta er útttagasti hluti flokks sem í heild ber heitið: *Iceland's Difference (Sérkenni Íslands)*. © fyrir ljósmynd, 1998, fyrir hönnun og texta, 2002, Roni Horn. Fríða Björk Ingvarsdóttir þýddi.

HELLO PUSSY CAT. I was working in a school in Reykjavík for a few days where I found this kitten. It was the winter of 1998. Her fur was so soft, like lamb's ear. Her peculiar vulnerability made it seem even softer. The school children that petted her thought so, too. They put their cheeks to her stomach to feel just how soft. I put her down on the blue linoleum floor and took this picture.

At the time I found her I was photographing all the native animals of Iceland of which the common house cat is not one. But I couldn't resist. Kitty's on the prowl. And even though it's only a linoleum jungle her predatory stance is real. And while she is only visible from behind—her character is recognizably curious and pert, even frisky. Her gaze though unseen is strongly present. And though we cannot see what she is looking at we know it is there.*

<div align="right">(No. 20, Iceland's Difference, October 12, 2002)</div>

* See next installment of *Iceland's Difference*, Lesbók, due out October 19, 2002.

HALLÓ KISULÓRA.

Ég var við vinnu í skóla í Reykjavík í nokkra daga þegar ég fann þennan kettling. Það var veturinn 1998. Feldurinn á honum bjó yfir óvenjulegri mýkt, líkt og lambseyra. Vegna þess hve hann var einkennilega varnarlaus, virtist hann jafnvel enn mýkri. Skólabörnin sem struku honum voru sammála, svo þau lögðu vanga sína að maganum á honum til þess að finna nákvæmlega hversu mjúkur. Ég setti hann niður á blátt línóleumgólfið og tók þessa mynd.

Þó ekki fyrr en ég var búin að dusta rykið af feldi hans sem var farinn að missa gljáa sinn, og þurrka burt rykið sem safnast hafði saman í augum hans. Ég náði því þó ekki öllu og ef þú gáir vandlega, kemurðu auga á rykagnir hér og þar og hvítar öður við hvarmana. Er ég horfi á þessa mynd sé ég að mér hefur líka sést yfir rykkorn á snoppunni á honum. Og jafnvel þó skin augna hans sé dempað af óhreinindum við jaðrana, má samt sjá mig og hluta af líkum hinni endurspeglast í sjáöldrunum.

En tókstu eftir litla skarðinu í nefið á honum og rifunni við tárakirtilinn? Og hvað með augun? Tókstu eftir hvað augun í honum eru undarleg? Það tók mig dálitla stund að átta mig á því – þó hann stari svona beint framan í mann – augun eru of stór. Það gerir hann reyndar framandi í útliti, jafnvel eins og hann sé í útrýmingarhættu – eða

hvað finnst þér? Þess vegna trúir fólk mér ekki þegar ég segi því að hann sé bara ósköp venjulegur húsköttur. Yfirleitt heldur fólk að hann sé gaupa eða eitthvert annað sjaldgæft dýr. En þetta er bara lítil kisa. Það er satt – bara venjulegur húsköttur, bara kettlingur, einungis lítil kisulóra.

*Sjá síðasta hluta Iceland's Difference (Sérkenni Íslands), Lesbók 12. október, 2002.

Þetta er tuttugasti og fyrsti hluti flokks sem í heild ber heitið: Iceland's Difference (Sérkenni Íslands). © fyrir ljósmynd, 1998, Roni Horn. © fyrir hönnun og texta, 2002, Roni Horn. Fríða Björk Ingvarsdóttir þýddi.

HELLO PUSSY CAT. I was working in a school in Reykjavík for a few days where I found this kitten. It was the winter of 1998. Her fur was so soft, like lamb's ear. Her peculiar vulnerability made it seem even softer. The school children that petted her thought so, too. They put their cheeks to her stomach to feel just how soft. I put her down on the blue linoleum floor and took this picture.

But not before dusting off her coat which was losing its luster and wiping away the lint that had gathered in her eyes. I couldn't get all of it though. If you look carefully you can see stray bits here and there, and white specks dotting the rims. As I look at this picture I see that I missed some crumbs as well, stuck in the fur around her mouth. And even though the shine of her eyes is matted with dirt around the edges, you can still see me and something of a blue sky reflected in her pupils.

But then there's the tiny chip in her nose and the rip in her tear duct? And what about her eyes? Did you notice them? It took me awhile to see it—staring me in the face the way they did—the eyes are so big. It makes her look exotic though, even a little endangered, don't you think? People don't believe me when I say she's just a plain old cat. Mostly they think she's a rare animal. But she's really just a cat. Just a common house cat, only a kitten, a little pussy at that.*

<div align="right">(No. 21, Iceland's Difference, October 19, 2002)</div>

* See No. 20, *Iceland's Difference*, Lesbók, October 12, 2002.

REFUR? – EÐA BARA BRAGÐAREFUR?

*Sjá síðasta hluta *Iceland's Difference (Sérkenna Íslands)*, Lesbók 19. október, 2002.

Þetta er tuttugasti og annar hluti flokks sem í heild ber heitið *Iceland's Difference (Sérkenni Íslands)*. © fyrir ljósmynd, 1998 Roni Horn, © fyrir hönnun og texta, 2002, Roni Horn. Fríða Björk Ingvarsdóttir þýddi.

FOX?—OR JUST FOXY?

(No. 22, *Iceland's Difference*, October 26, 2002)

THE WIZARD OF OZ brought me Kansas, if only briefly when I was young. And to this day Kansas is still one of the places I've never been. But since I watched Judy Garland journey to Oz, Kansas has inhabited my imagination, and Todo too. And in this way we come to dwell in places we've never been. It's a form of dreaming — these unseen places, these places only known of through rumor, word-of-mouth, flights of fancy and a map — or no map — just a story told. And we need the idea of them, the idea — that from early childhood has become a part of our being.

The existence and well being of these unseen but accessible places is of vital consequence to all of us. They dominate the geography of our imagination and dreams. To recognize that some of these places are real is essential to the life of our dreams. They offer us extension and breadth, hope and faith. We need these places that we've never traveled to, these places we may never go to. We need them, not for escape, but for measure; of all the places we have been to, and even — of ourselves as well. We need them as a way of balancing what is, with what might be; And as a way of understanding the scope of things, of admitting that the things beyond us are also the things that define us. These are places that are at once both actual and acts of imagination. They function to keep the world large and unimaginable.

These rarely experienced places — are no less real and valuable than those we occupy daily; no less inhabited by us than our most familiar and intimate places. In acknowledging this unseen but visible world we understand that we are something more than the body we inhabit and the things we consume; and that we dwell in places beyond our immediate perception or reach — in places that are out there maintaining the view, though mostly unwitnessed, so that we may see beyond our sight.

It is common to believe that since we will never travel to these places, their lose will have no effect on us. Or that losing a place that is not occupied by humanity is a lose of no importance. That going from unseen to non-existent will make no difference. But the difference is profound. Not only are we losing the prime infra-structure of our imagination but the basis of our environmental well-being as well. To undervalue them, to allow them to be destroyed, is to live in a smaller and meaner world.

This is the 23rd in a series collectively entitled: *Iceland's Difference*. © For design and text, 2003, Roni Horn. Translated by Frida Björk Ingvarsdóttir.

THE WIZARD OF OZ brought me Kansas, if only briefly, when I was young. And to this day Kansas is still one of the places I've never been. But since I watched Judy Garland journey to Oz, Kansas has inhabited my imagination, and Toto too. In this way we come to dwell in places we've never been. It's a form of dreaming—these unseen places, only known through rumor, word of mouth, flight of fancy, a map—or no map, just a story told. We need the idea of them, the idea that from early childhood has become a part of our identity.

The existence of these unseen but accessible places is of profound consequence. They dominate the geography of our imagination and dreams. To recognize that some of them are real is essential to the life of our dreams. They offer us extension and breadth, hope and faith. We need these places that we've never traveled to, that we may never go to. We need them not for escape, but for measure: of all the places we have been to, and of ourselves as well. We need them as a way of balancing what is with what might be, and as a way of understanding the scope of things, of admitting that the things beyond us are also the things that define us. These are places that are at once both actual and acts of imagination. They function to keep the world large, hopeful, and unknown.

These rarely experienced places are no less valuable than those we occupy daily, no less inhabited by us than our most familiar and intimate ones. In acknowledging them we understand that we are something more than the body we inhabit and the things we consume, and that we dwell in places beyond our immediate perception or reach—so that we may see beyond our sight.

It is common to believe that because we will never travel to them, their loss will have no effect on us. Or that losing a place that is not occupied by humanity is a loss of no importance; that going from unseen to nonexistent will make no difference. But the difference runs deep. We are losing the core infrastructure of our imagination.

(No. 23, *Iceland's Difference*, 2003, unpublished)

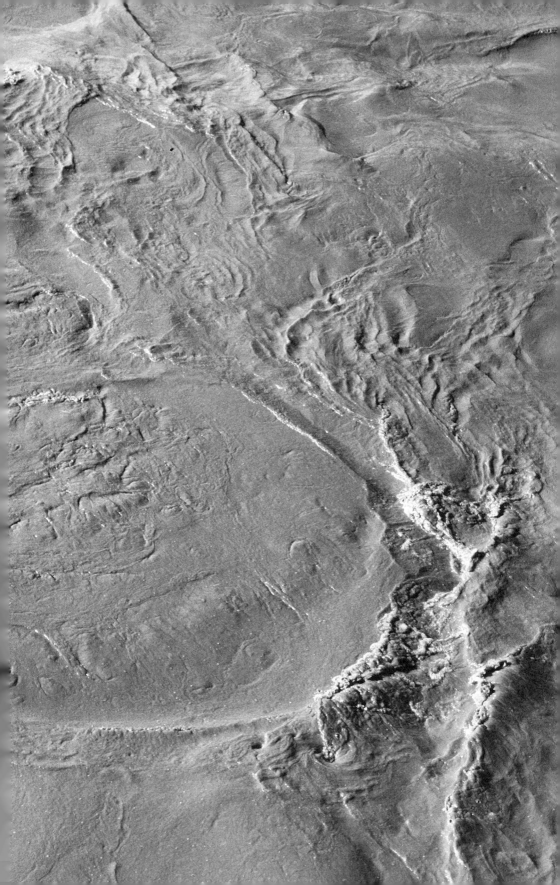

Colophon

Photography

Courtesy of the artist and Hauser & Wirth:

Map of Stories and *Iceland's Difference*: Ron Amstutz, New York.

Courtesy of the Roni Horn Studio, New York:

River Skaftá, Iceland, 2002–3, and Carte de L' Islande (p. 114).

Map of Stories (v. 3), 2019 (pp. 80–81)

Roni Horn

Collage on special edition map

10¾ × 13¼″

Author's Acknowledgments

For support in the development and publication of *Weather Reports You*, much thanks to
Gerhard Steidl (Steidl, Göttingen), and James Lingwood (Artangel, London).

For critical and editorial advice, I am grateful to Michelle Komie at PUP, and also to Julie Ault,
Jerry Gorovoy, and Gary Indiana.

For publication of *Iceland's Difference* in his newspaper, *Morgunblaðið*, Styrmir Gunnarsson.

For her thoughtful and practical contributions to *Island Zombie*, much thanks to Abby Merrick
at the Roni Horn Studio.

Design

Takaaki Matsumoto, Matsumoto Incorporated, NY, NY